France

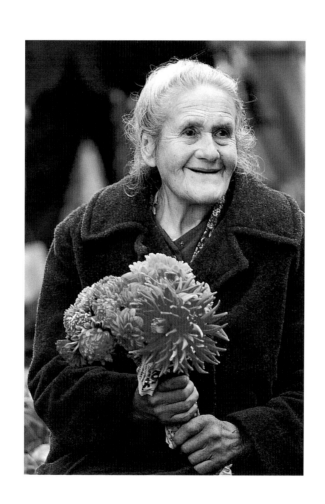

First published in Great Britain in 1998 by
Colin Baxter Photography Ltd
Grantown-on-Spey, Moray PH26 3NA

A CIP catalogue record for this book is available from the British Library

ISBN 1 900455 50 1

Printed in Hong Kong

Front Cover Photograph: Château de la Malartrie, La Roque-Gageac, Dordogne
Back Cover Photograph: Le Prunier, Périgord Blanc, Dordogne

FRANCE

COLIN BAXTER

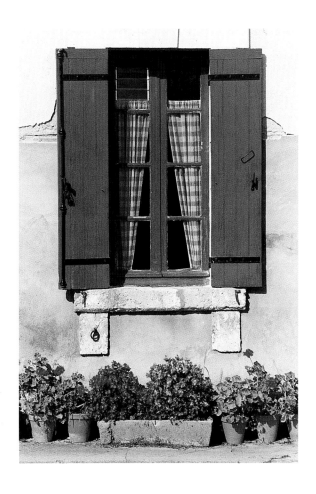

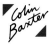

Colin Baxter Photography, Grantown-on-Spey, Scotland

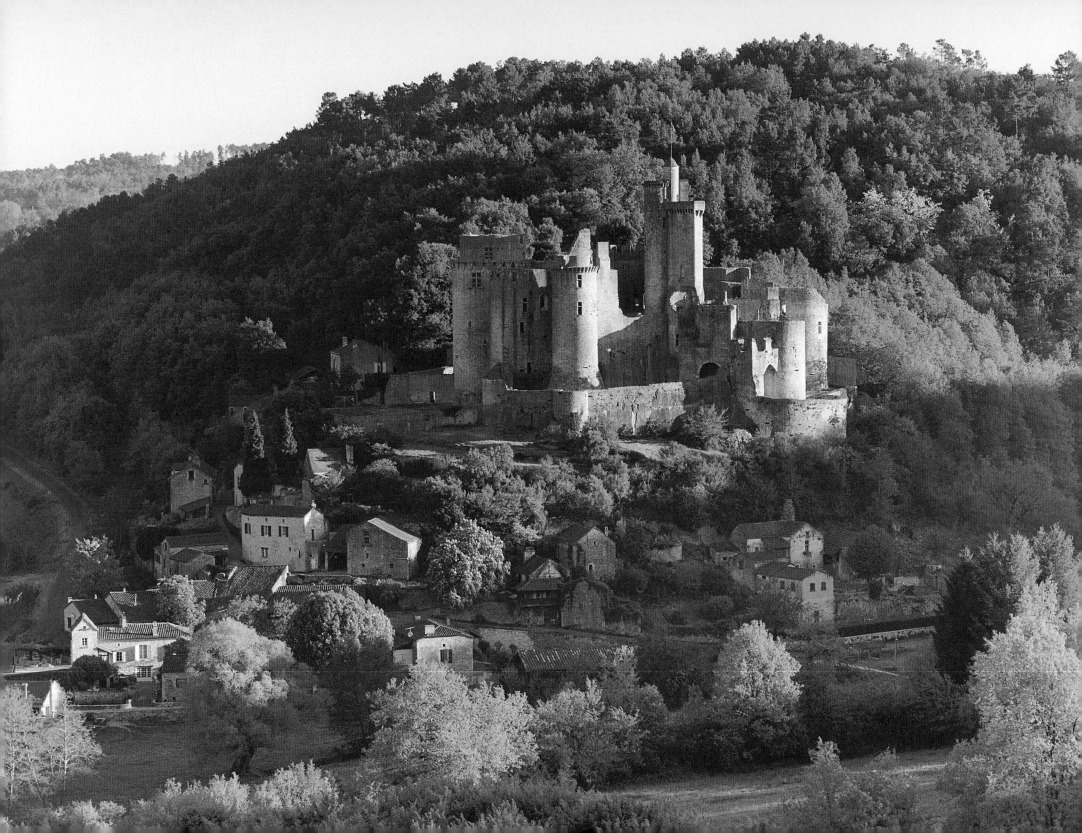

FRANCE

It is a combination of many quite ordinary things that produces the special feeling of just being in France. Doors, windows, shutters and roofs blend in distinctive architectural styles across the many diverse regions. Market towns bustle with atmosphere and colour, small villages hold a timeless calm, and restaurants throughout the country indulge in the joy of good food and fine wine.

Gastronomy is of course one of France's great strengths and it is wedded not only to a way of life but to the shaping of the landscape itself. There are over four hundred accredited wines produced in France, and large areas of the landscape are clothed with a fabric of vines in serried ranks; a mesh of crooked dark shapes in winter, overflowing with vibrant greens in spring and a glorious mass of oranges and reds during the autumn.

The landscape is wide and varied, and although plains cover much of the country, they are dissected by four great rivers and their tributaries; the Seine, Loire, Garonne and Rhône, as well as many other smaller rivers, producing a giant jigsaw of fertile valleys and gorges. France also has over three thousand kilometres of coastline and harvesting of the sea as well as the land contributes to a vast array of mouth-watering menus.

Snow is not uncommon in many regions, transforming the landscape into a less familiar guise, and often a heavy frost coats everything in the stillness of bright whites. It is amongst the snow-covered mountains of Europe's highest peaks on the border with Italy and Switzerland that the land contrasts dramatically with the plains to the north and west. Along France's southern border with Spain as well dramatic scenery dominates, with jagged peaks towering above the wooded slopes and lush pastures below. In the Massif Central, deep winding gorges have been carved for thousands of years amongst long extinct volcanos. The soil is rich and along with the crops, sheep and cows it supports, there are large tracts of natural woodland cloaking the slopes alongside deep meandering rivers. A quarter of France is in fact forest and in places still harbours wildlife species otherwise very rare in Western Europe.

It is however the history of France that has shaped the character of the landscape more than anything, and its legacy is everywhere. Monuments to the French Revolution abound, great Renaissance chateaux dominate their surroundings; Gothic architecture stands proud in towns and cities; the countryside overflows with a wealth of beautiful Romanesque churches; Medieval towns are remarkably intact; and in the south, impressive Roman structures have survived two thousand years of wars and weather.

France's unique blend of history and landscape is also transformed by the seasons, producing more than a lifetime of situations to experience, explore and indeed to capture with a camera. The photographs here are a selection of such places and moments across the country's differing regions. They are a personal collection gleaned from travels over many years and very much an indulgence in rural France, in the landscape, its towns, villages and buildings, from the humble to the grandiose. There is of course much more to explore and I will certainly, in the years to come, continue to enjoy discovering the visual delights France has to behold.

Colin Baxter

Bonaguil, Lot *(opposite)*

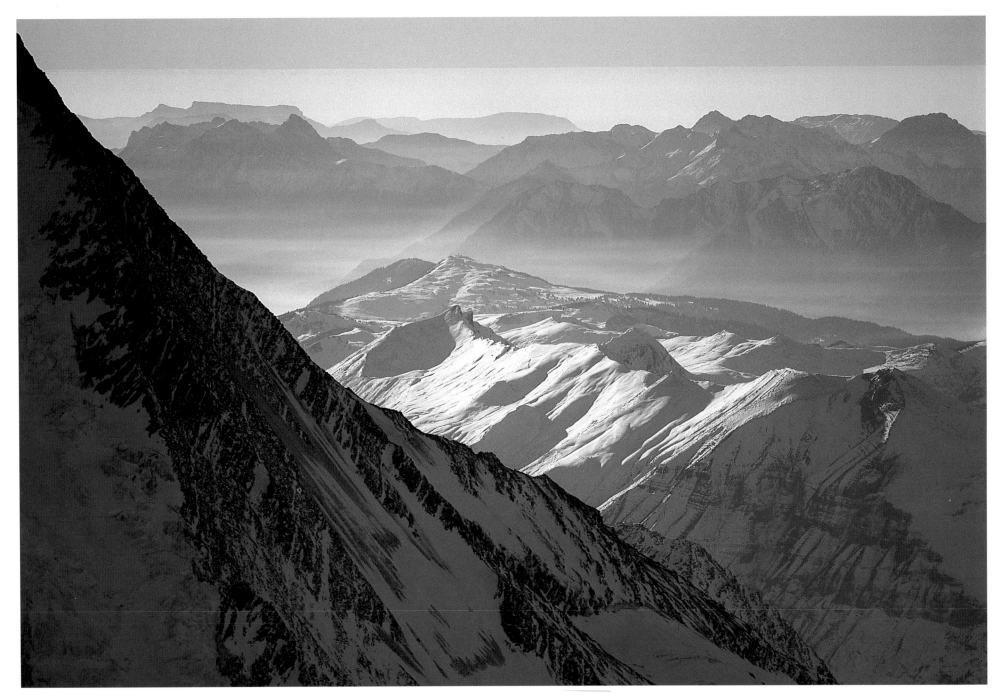

Mont Blanc, Haute-Savoie

Ingersheim, Alsace

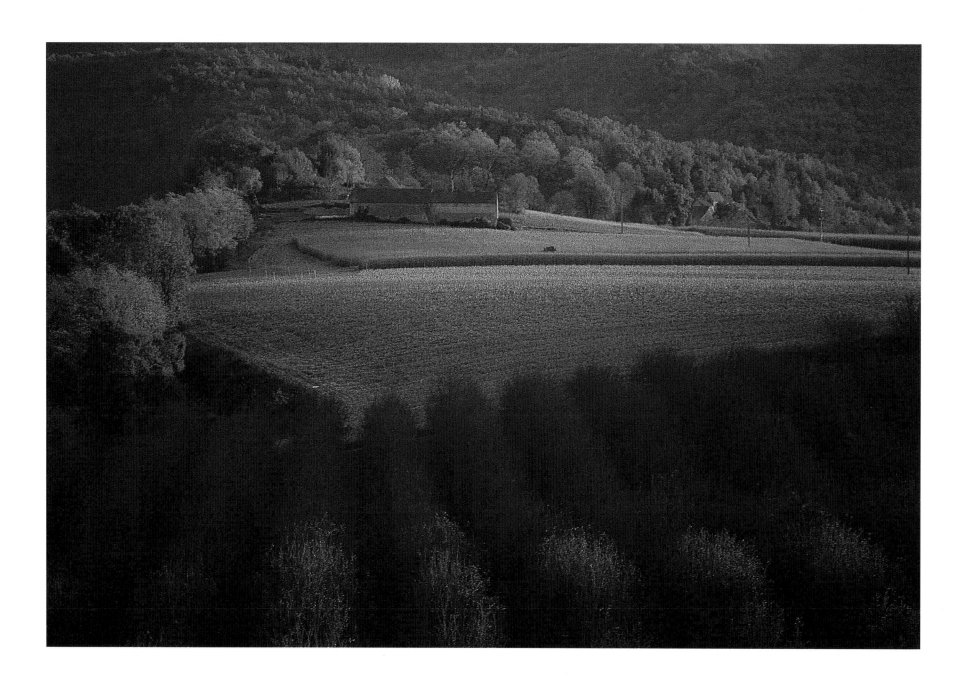

Cingle de Montfort, Dordogne

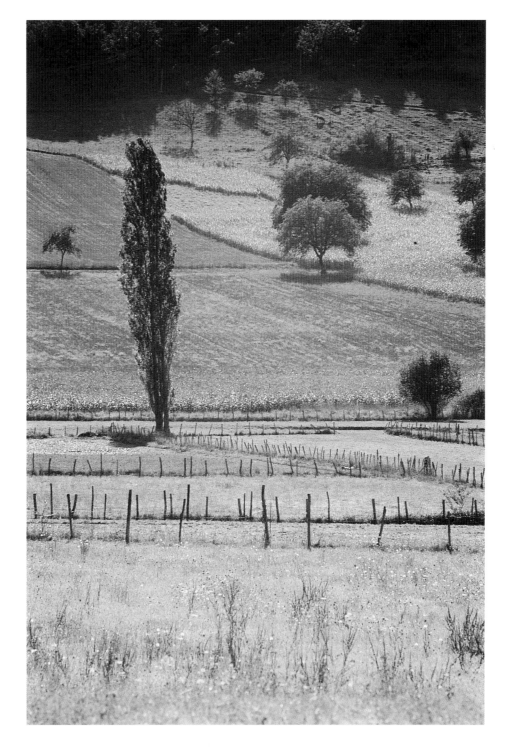

Vergt, Dordogne

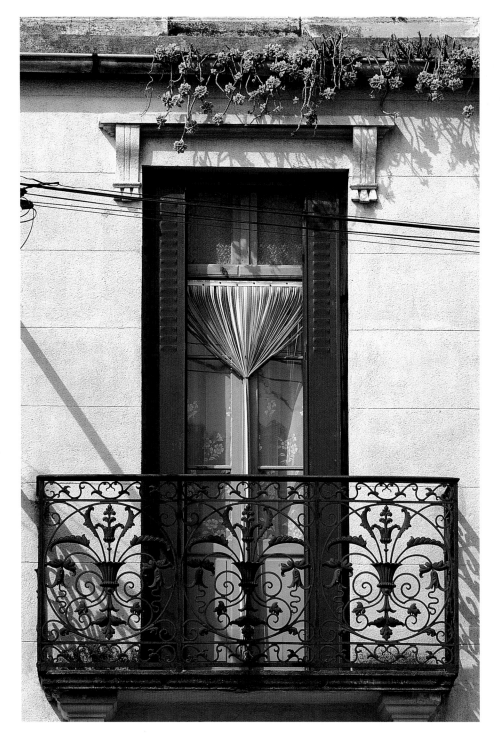

Sorède, Roussillon

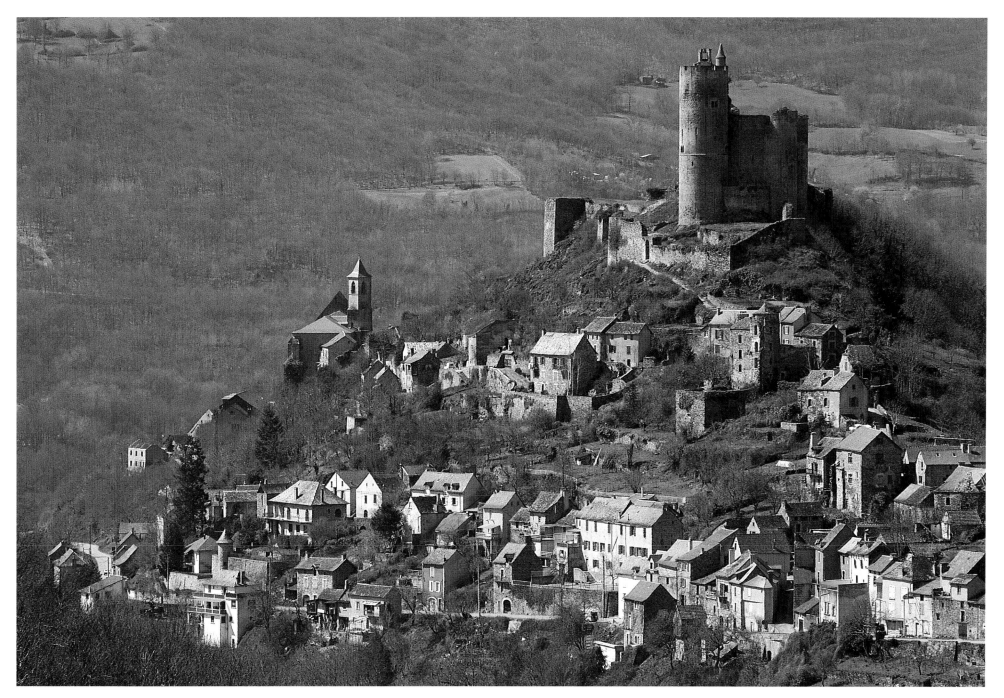

Najac, Gorges de l'Aveyron

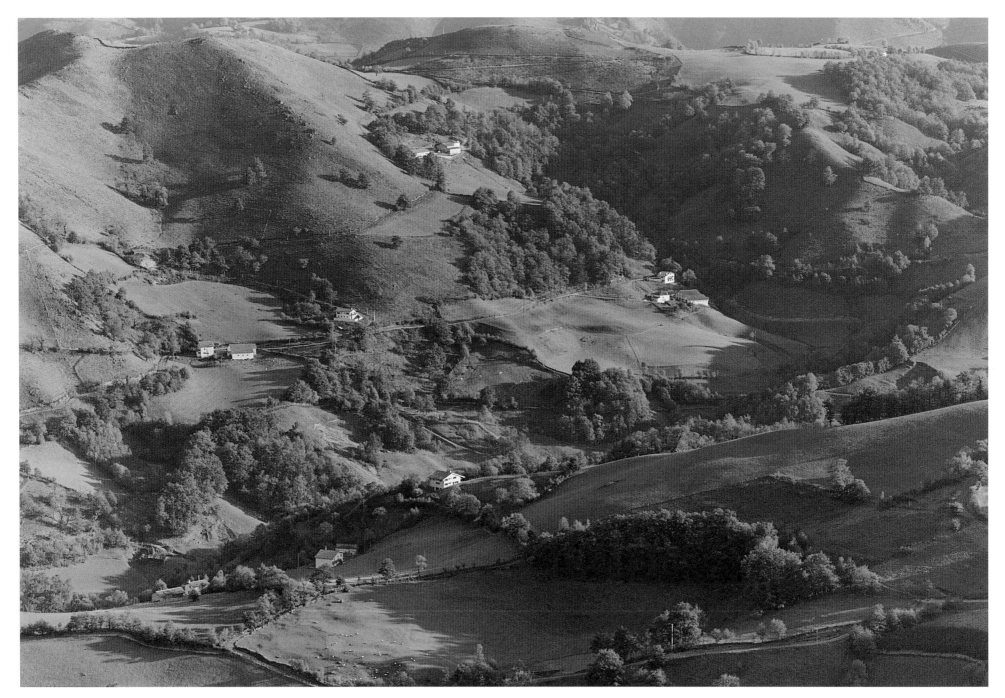

Apetchia, Pays Basque

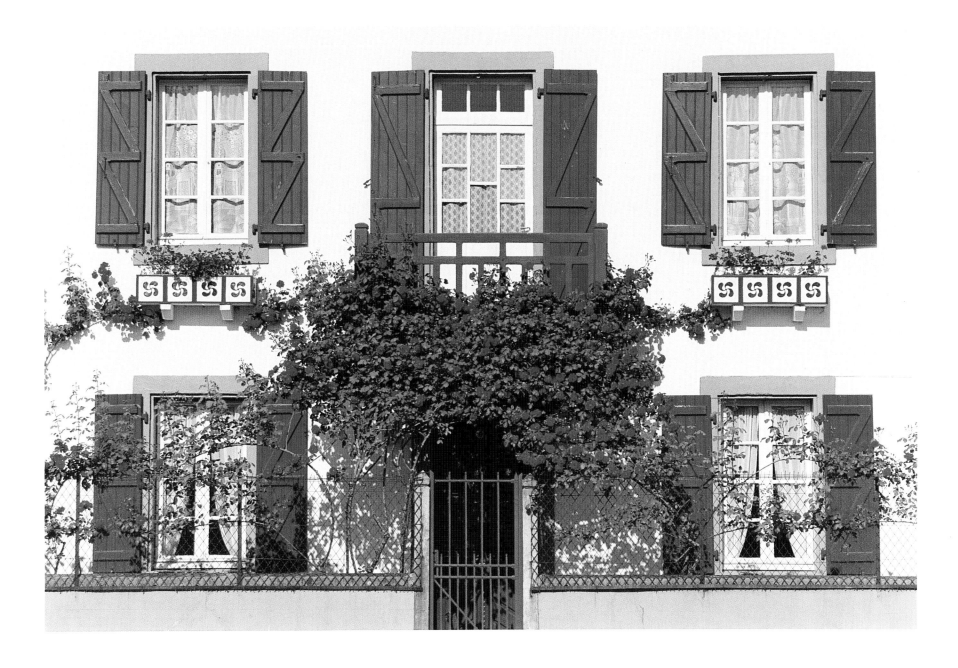

Saint-Michel, Pays Basque

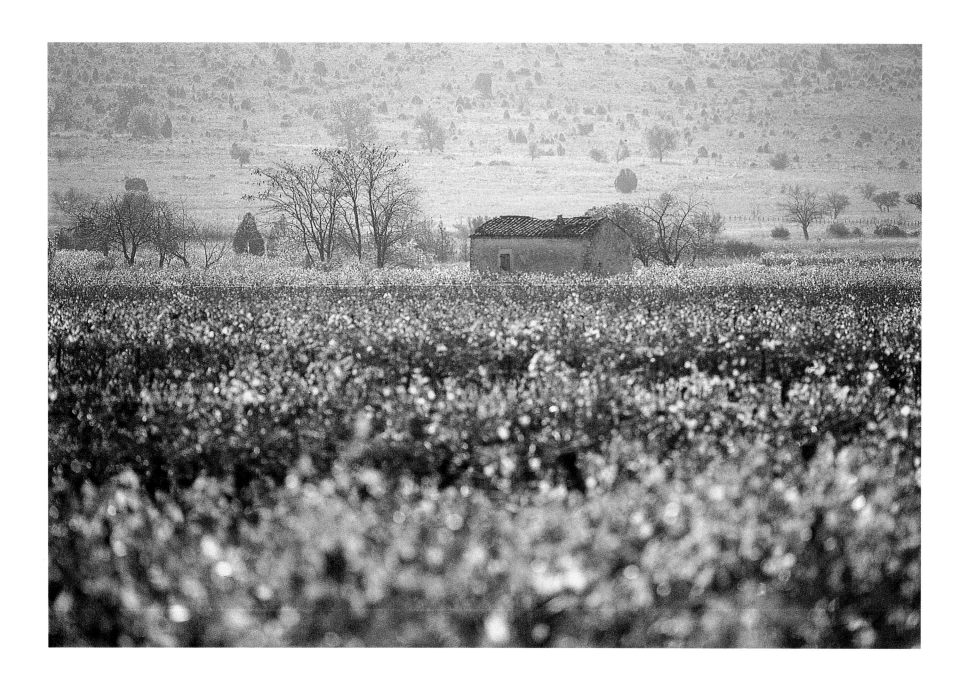

Moulès-et-Baucels, Hérault

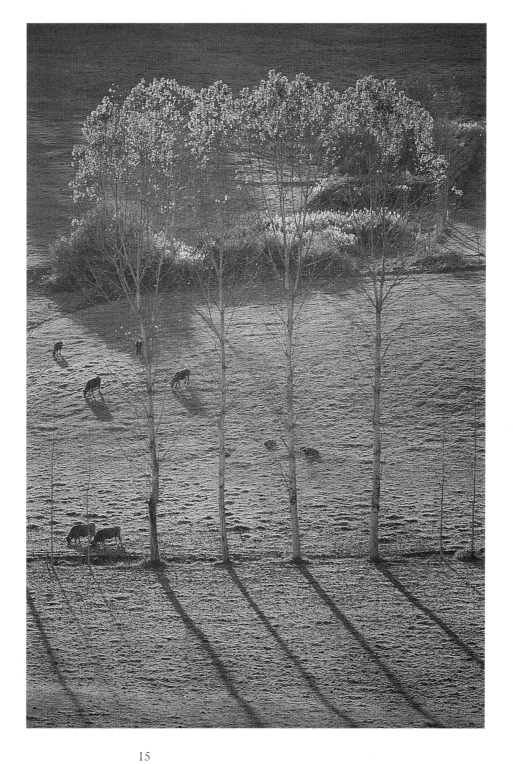

Périgord Noir

15

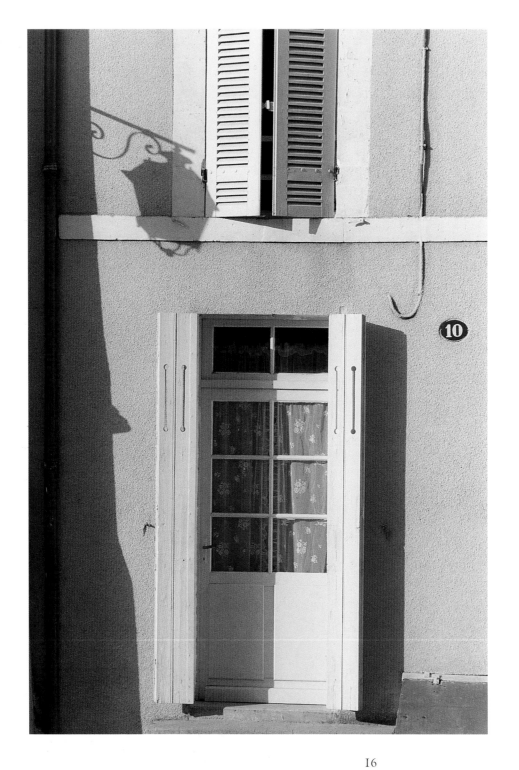

Ribérac, Périgord Blanc *(left)*
Le Moulin de Puy d'Ardanne, Vienne *(opposite)*

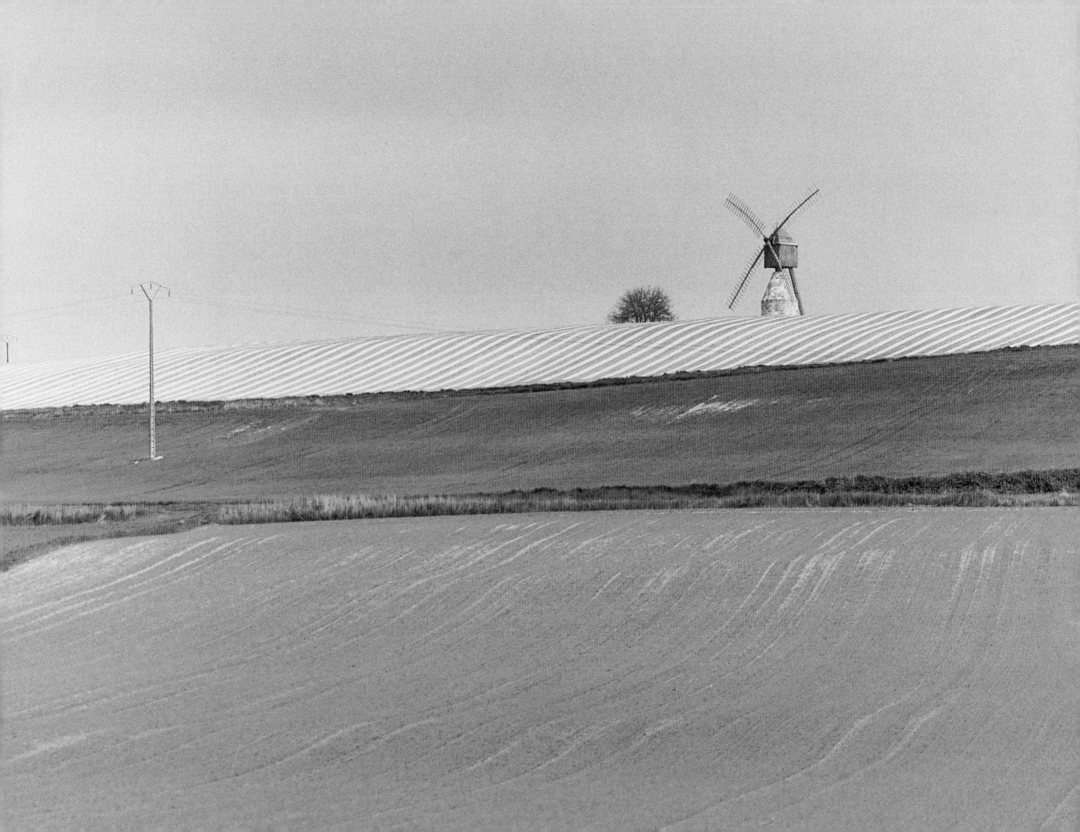

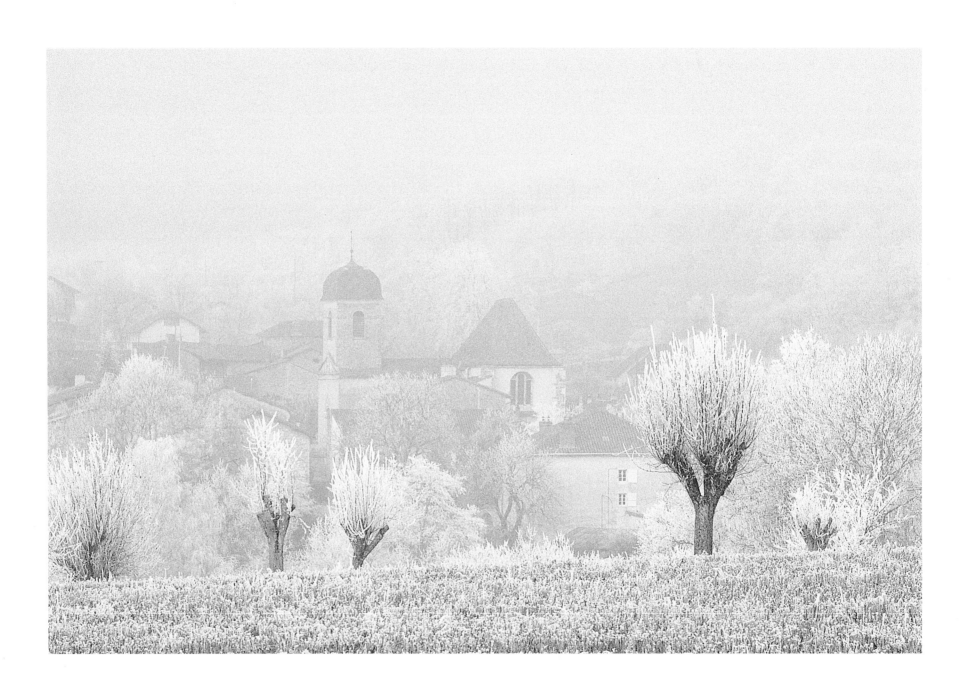

Journans, Ain

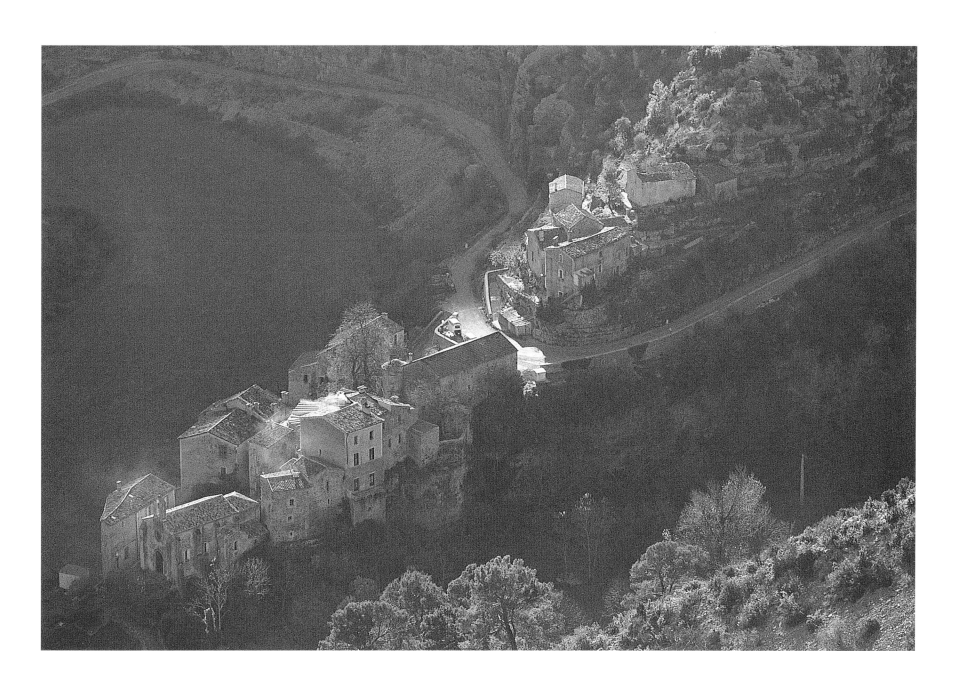

Cirque de Navacelles, Languedoc

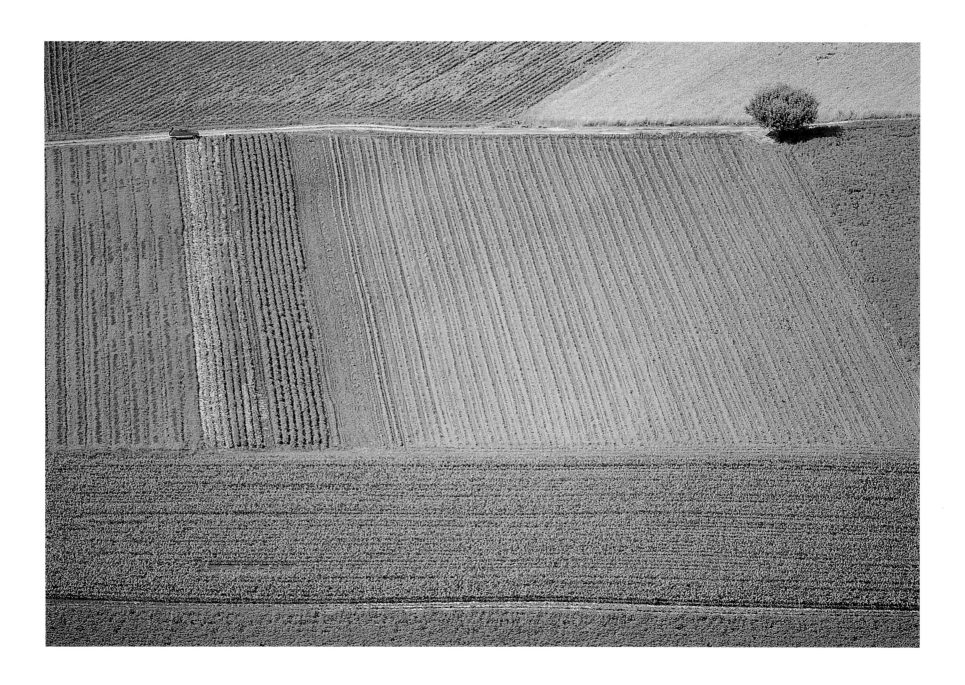

Cingle de Trémolat, Dordogne

Côte Vermeille, Pyrénées-Orientales

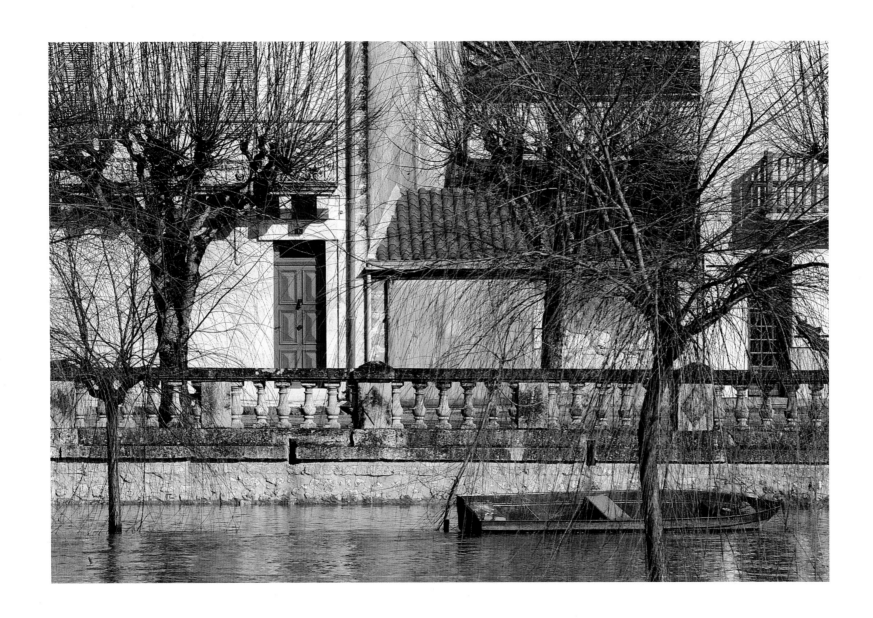

Castillon-la-Bataille, Gironde

22

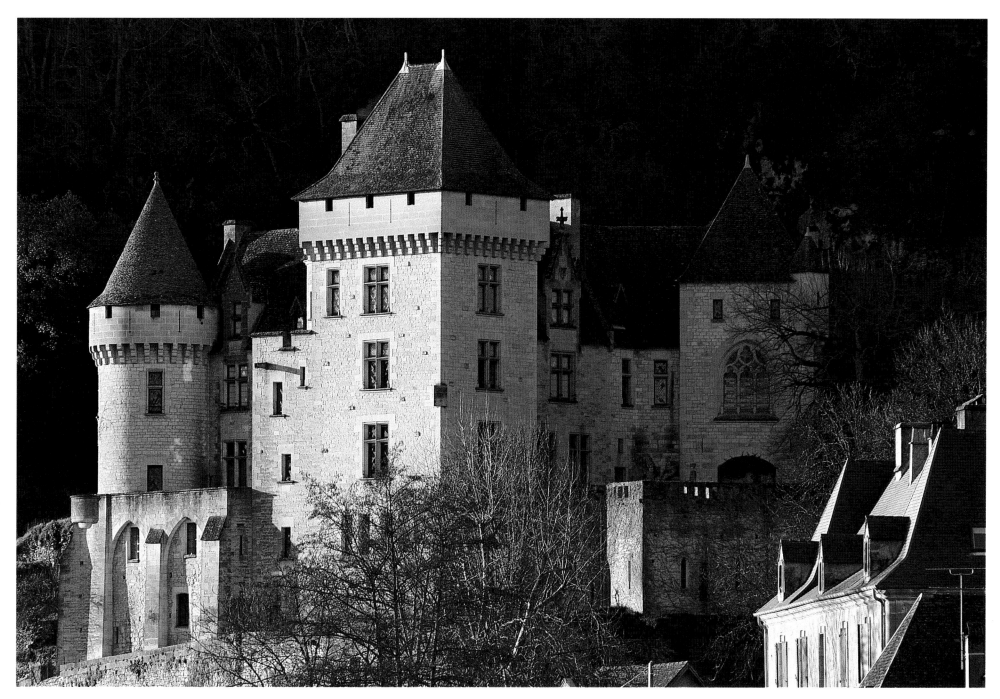

Château de la Malartrie, La Roque-Gageac, Dordogne

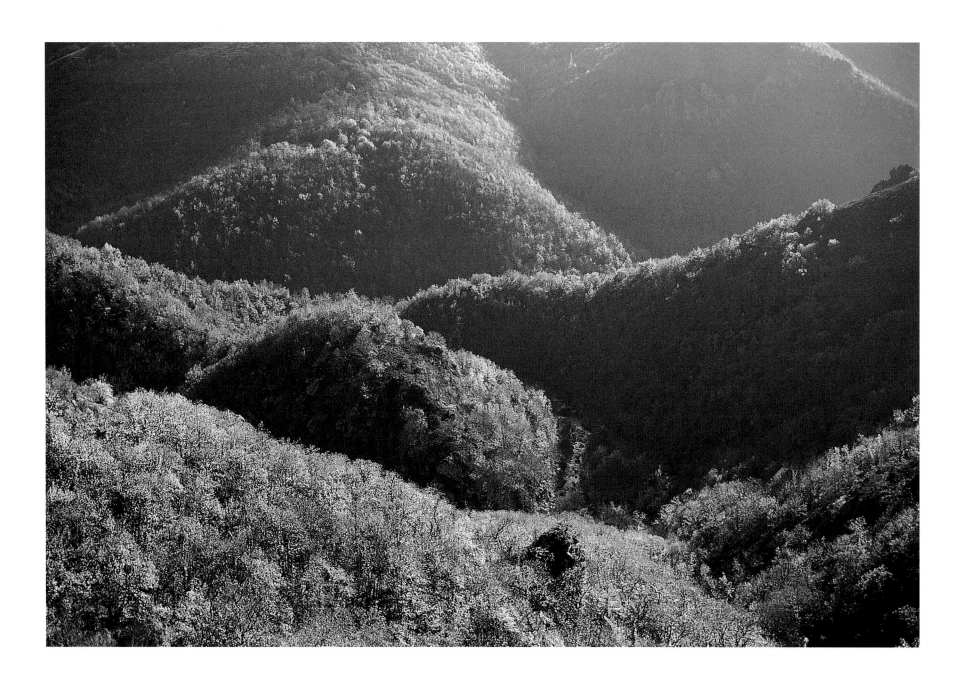

Gorges de la Dourbie, Cévennes

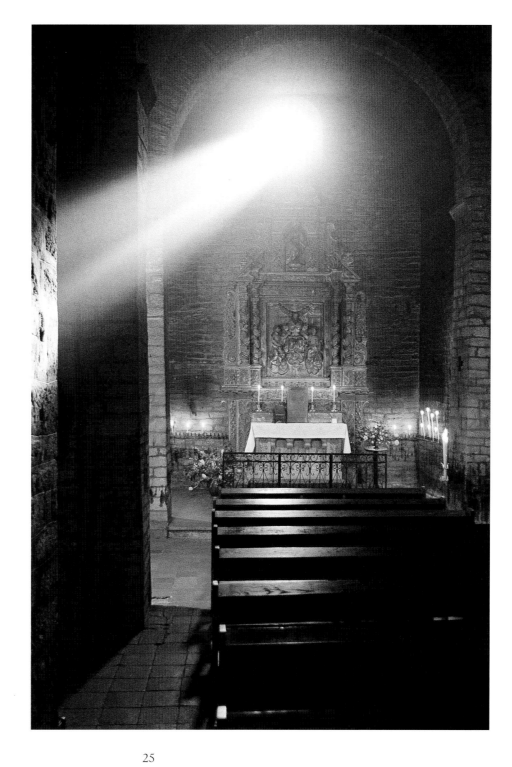

Prunet-et-Belpuig, Pyrénées-Orientales

25

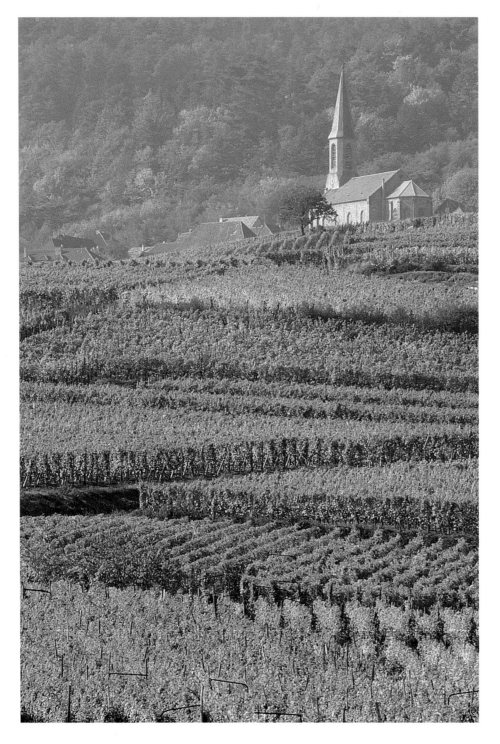

Haut-Rhin, Alsace

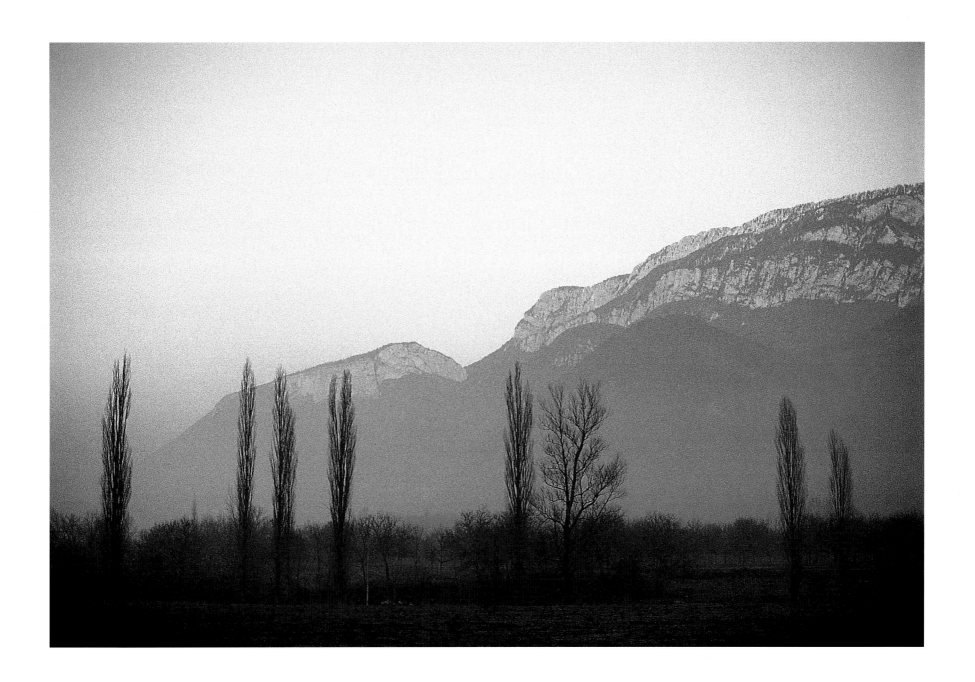

Izeron, Isère

27

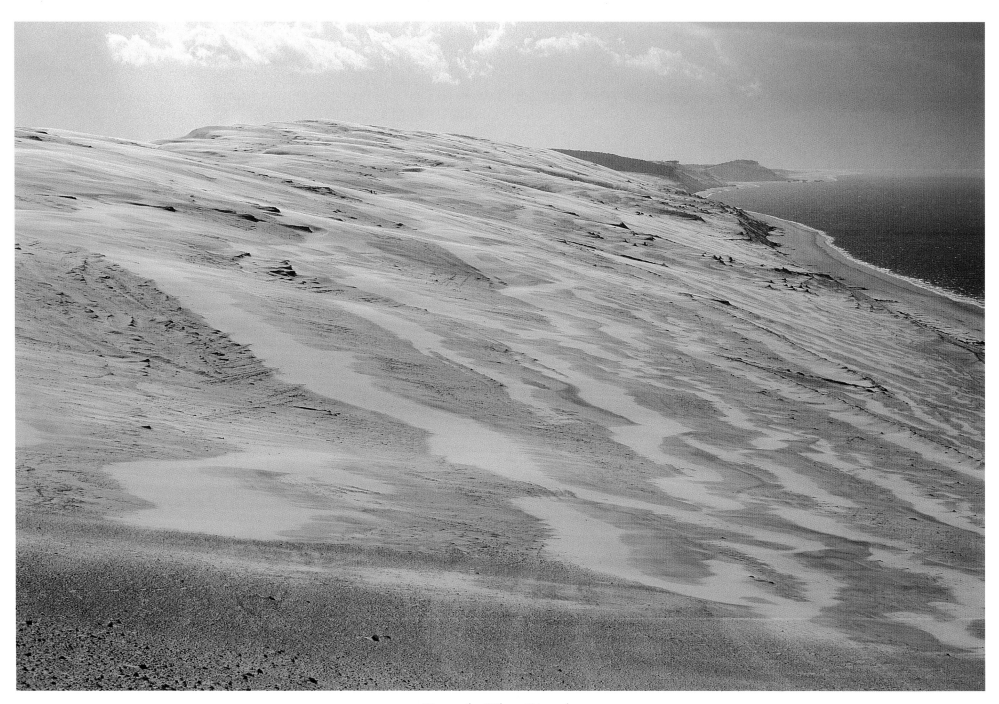

Dune du Pilat, Gironde

28

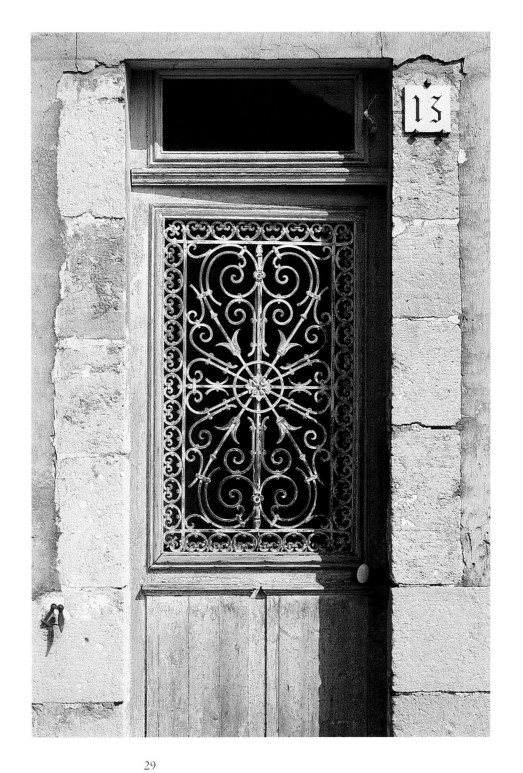

Pays de la Loire

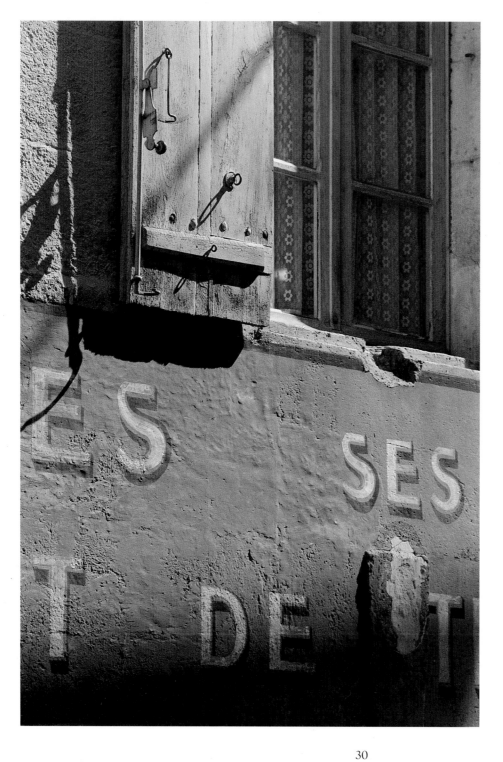

Périgord Blanc

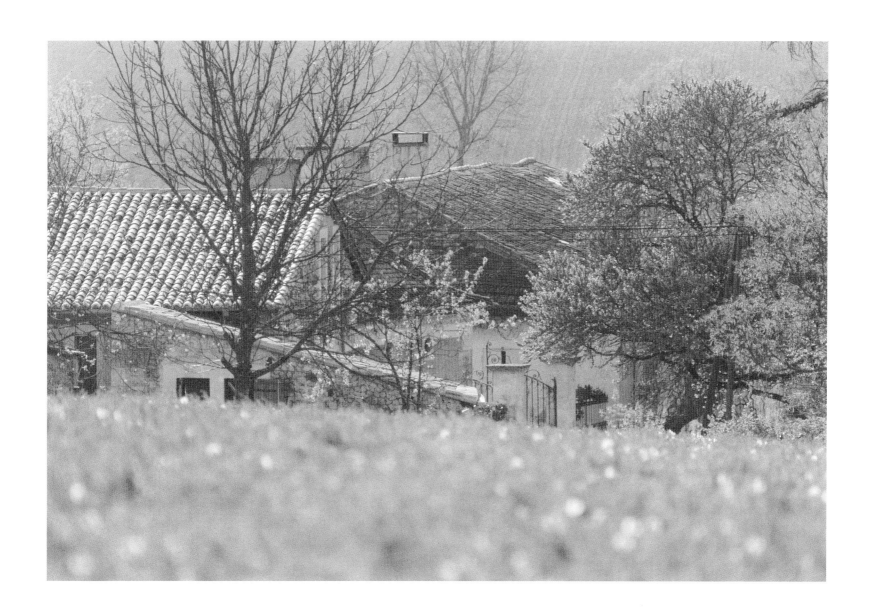

Le Prunier, Périgord Blanc

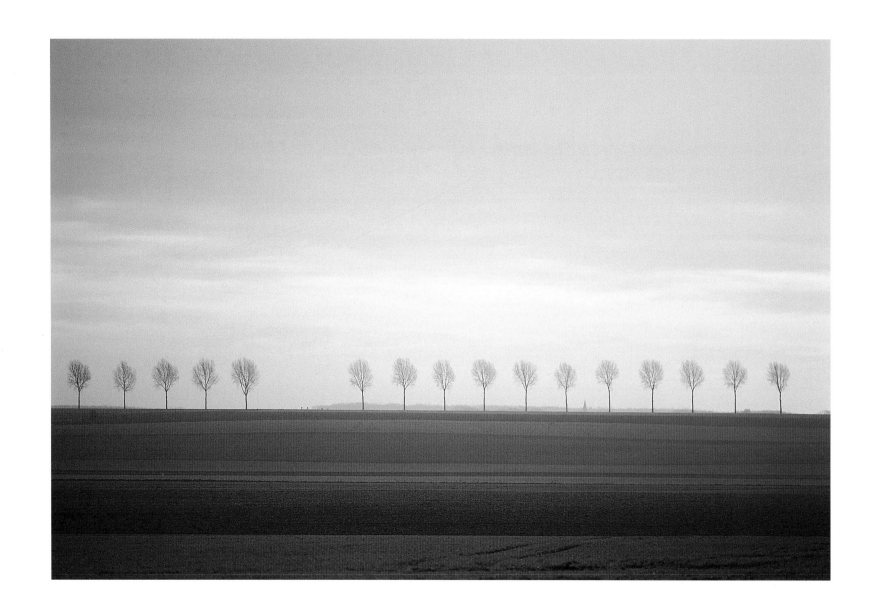

Pas-de-Calais

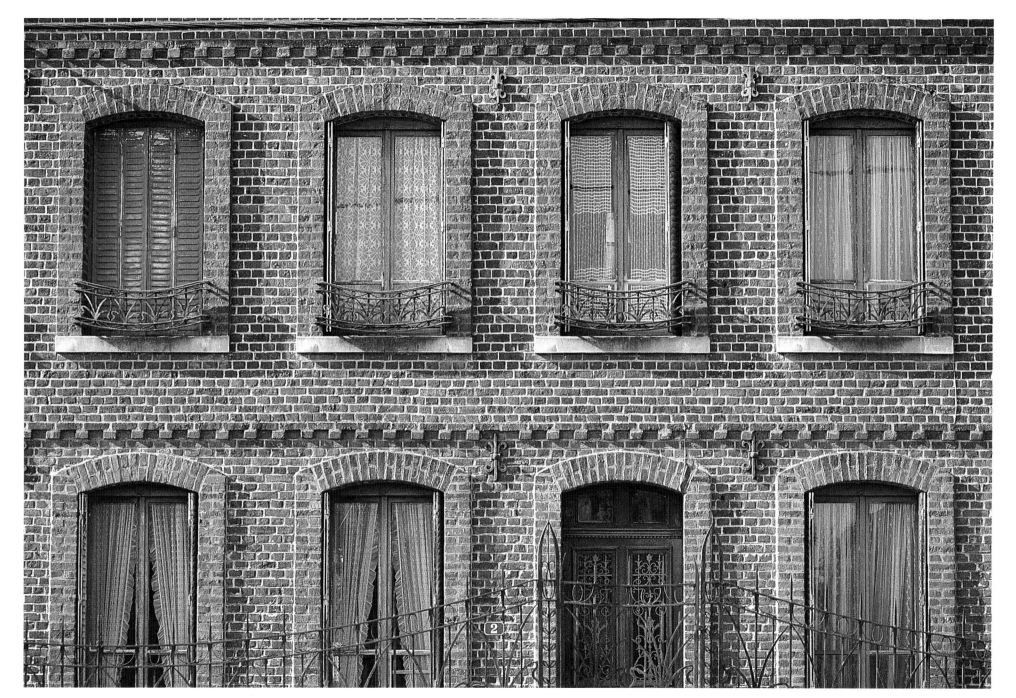

Normandie

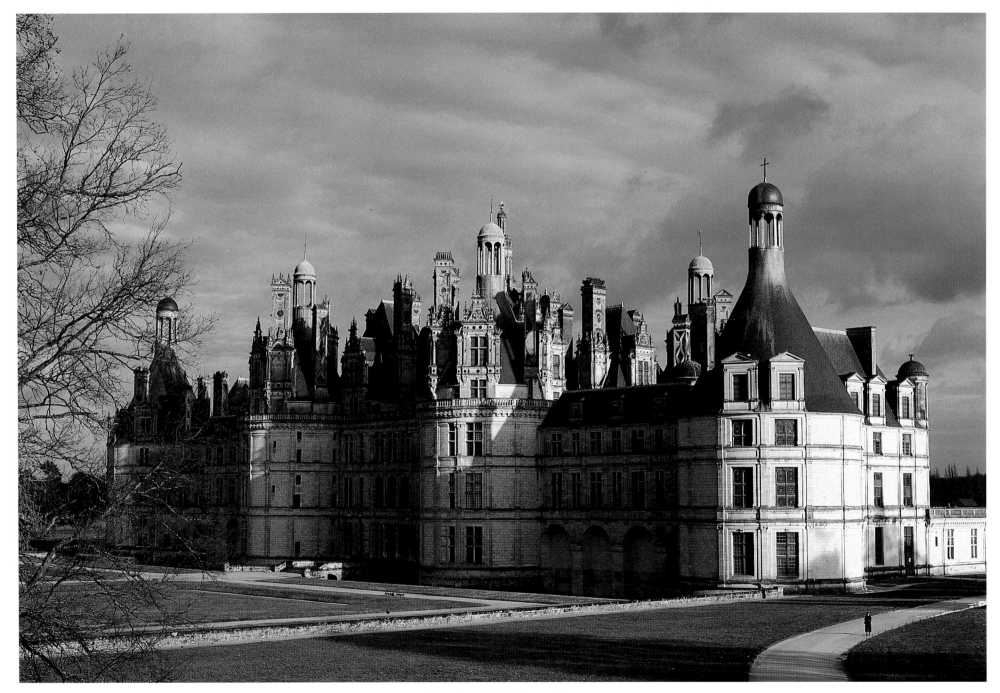

Chambord, Loir-et-Cher

34

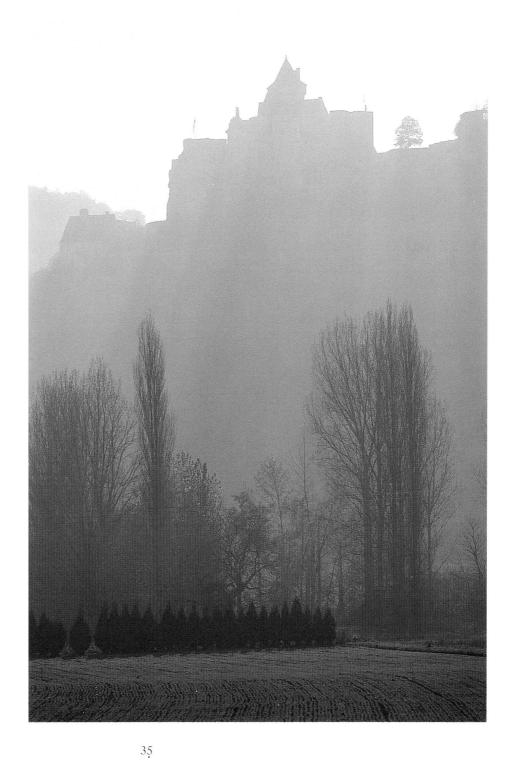

Castelnaud-la-Chapelle, Dordogne

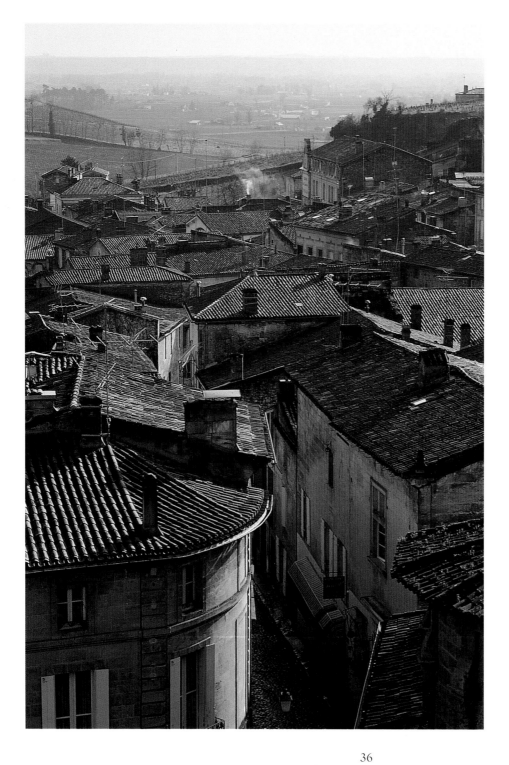

Saint Emilion, Gironde

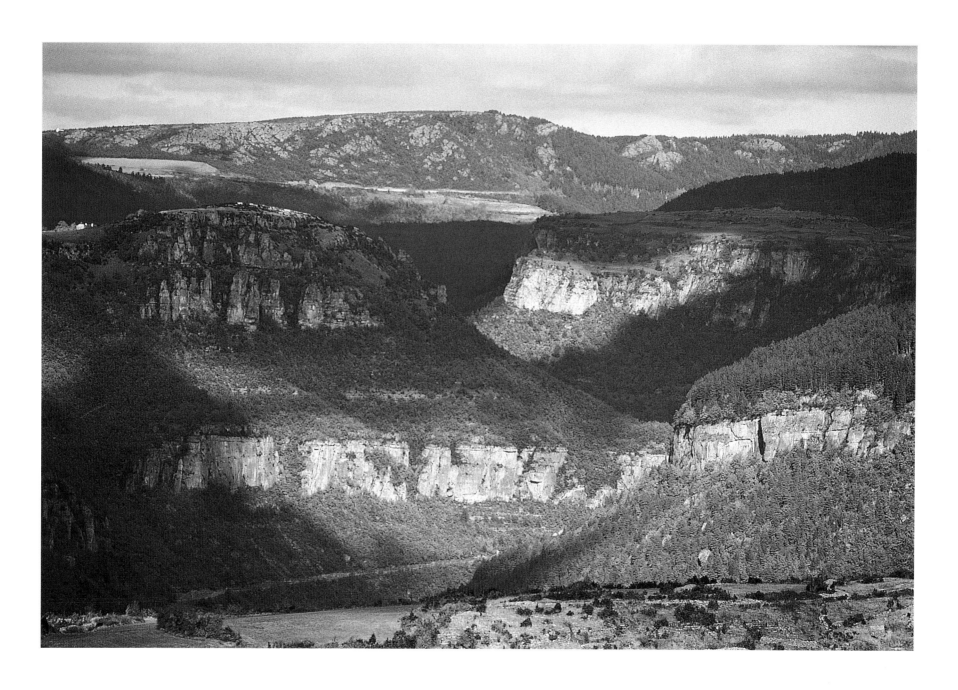

Causse Bégon, Cévennes

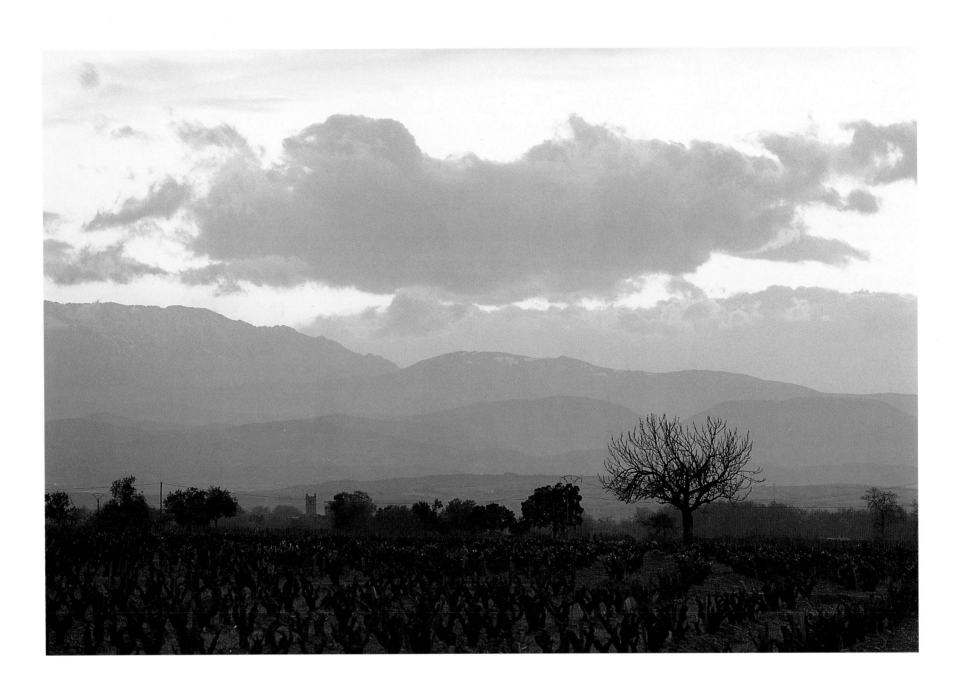

Chaîne des Albères, Pyrénées-Orientales

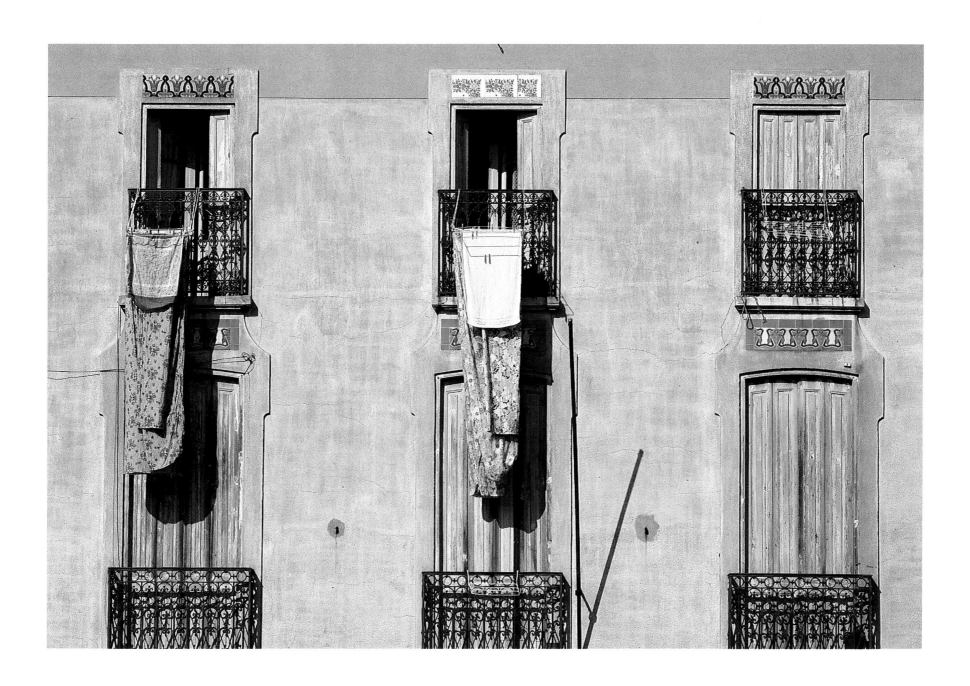

Collioure, Côte Vermeille, Pyrénées-Orientales

39

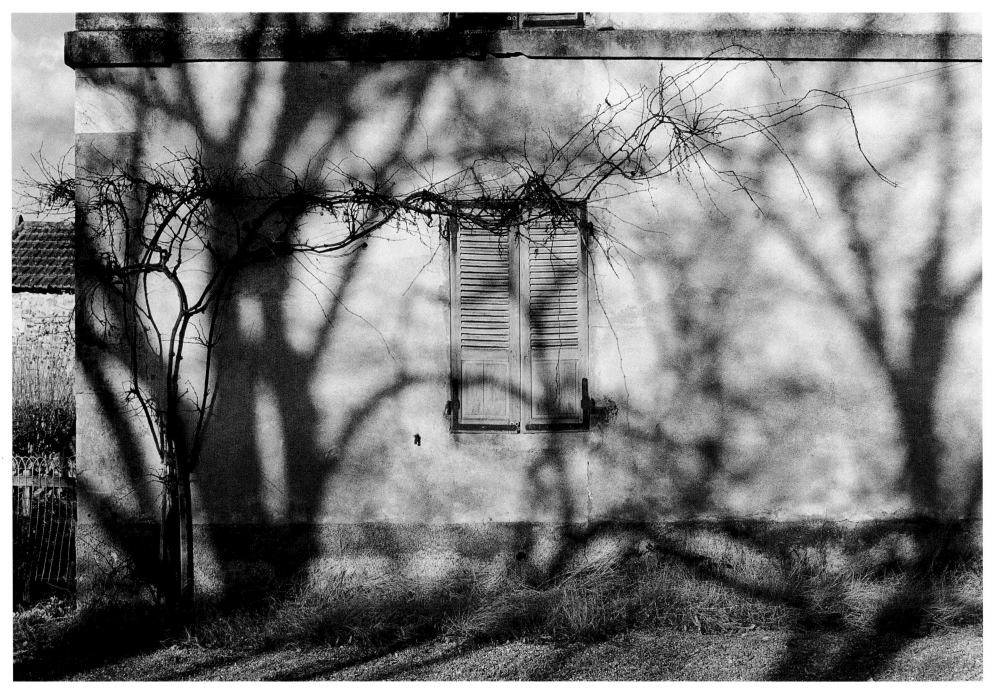

La Chambon, Saône-et-Loire

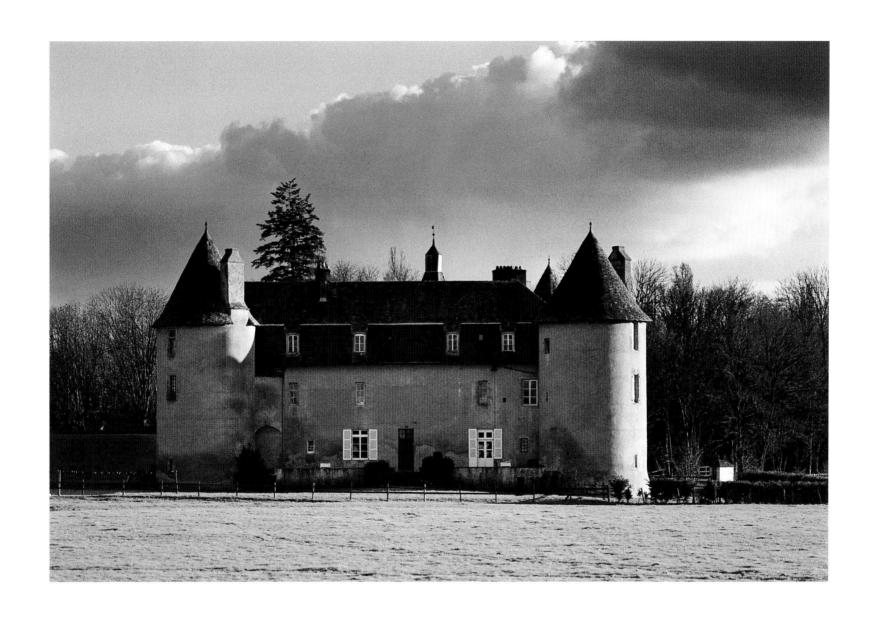

Arcy, Saône-et-Loire

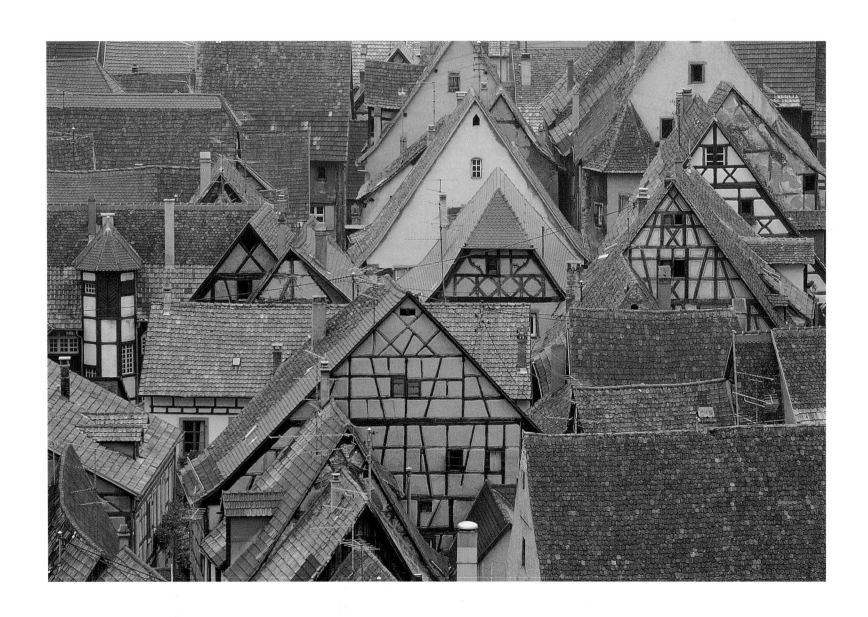

Ribeauvillé, Alsace

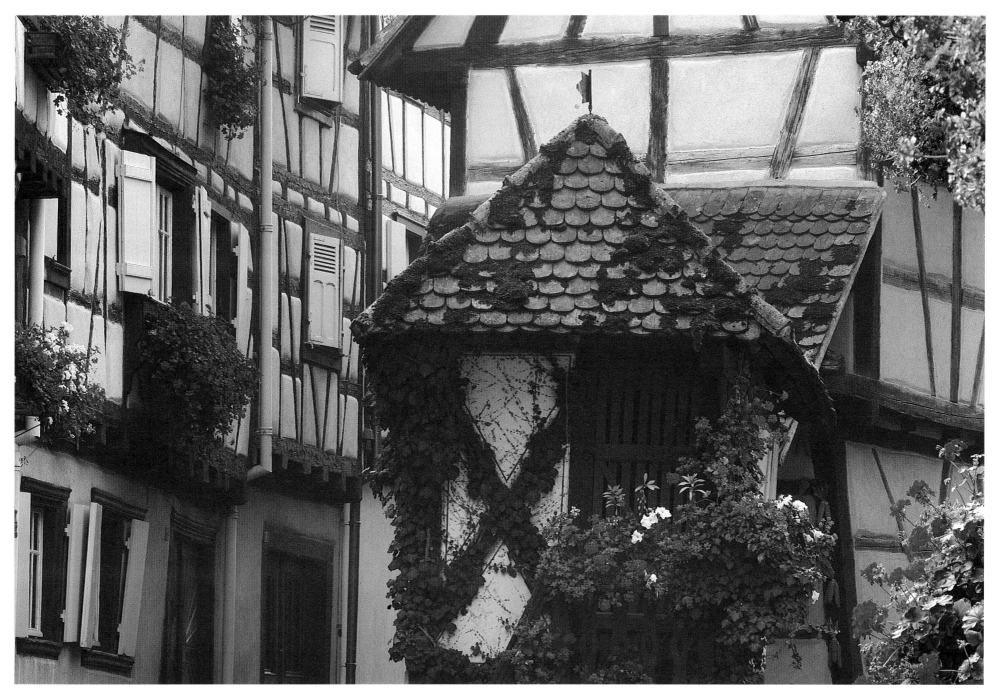

Riquewihr, Alsace

43

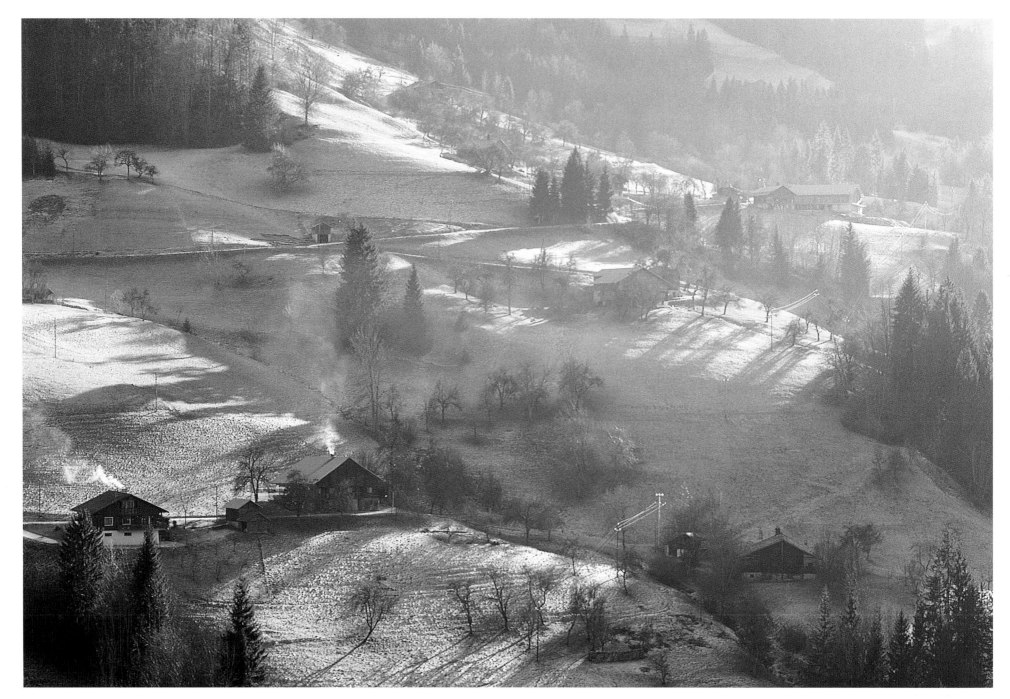

Plan-des-Berthats, Haute-Savoie

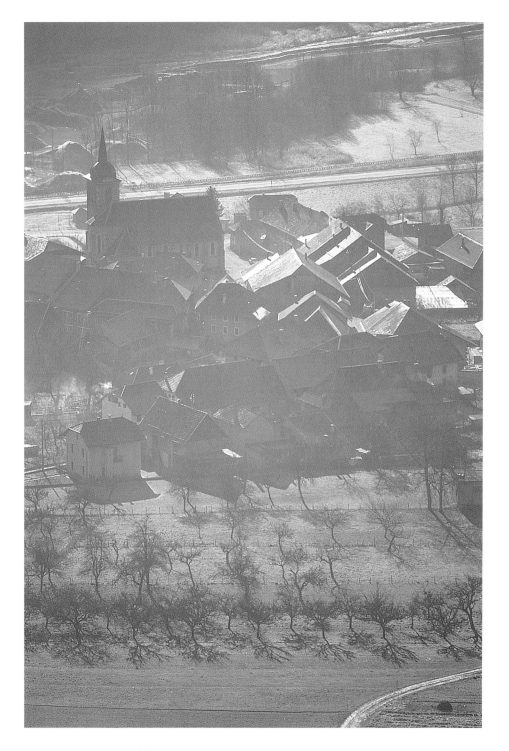

Marlens, Haute-Savoie

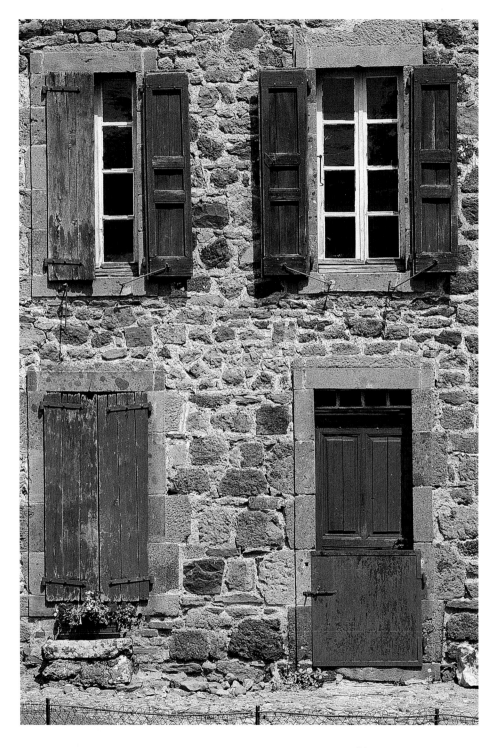

Salers, Cantal, Auvergne

46

Cantal, Auvergne

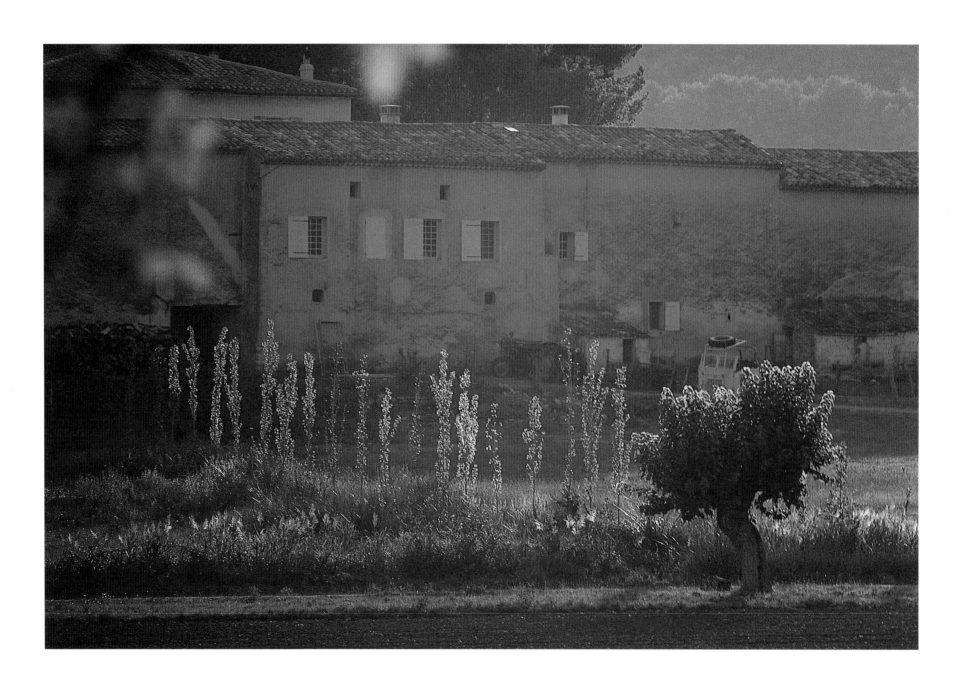

Amphoux, Provence

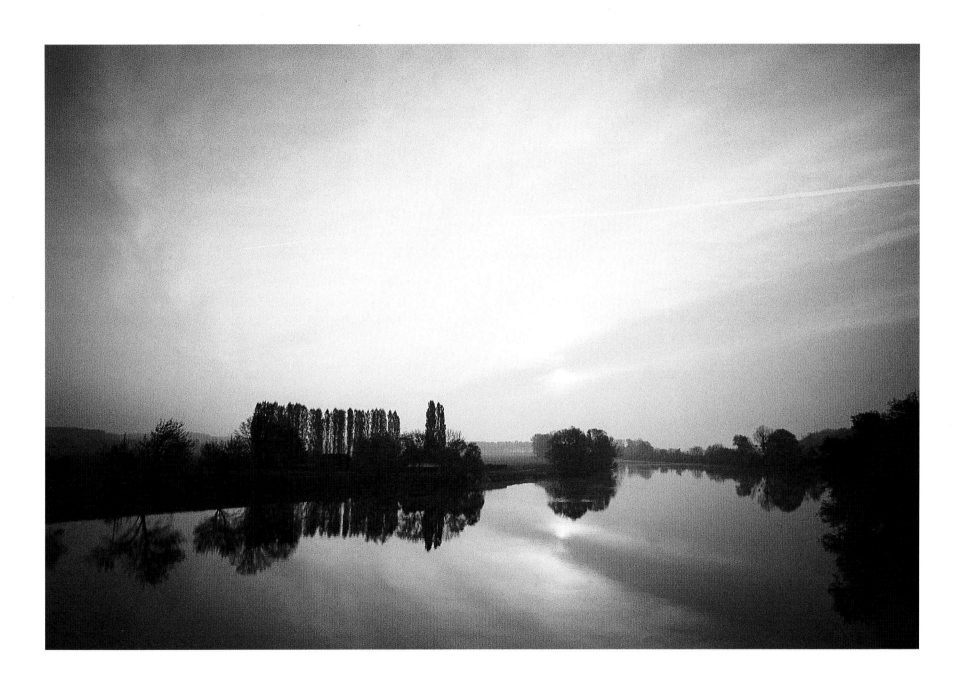

Le Cher, Indre-et-Loire

49

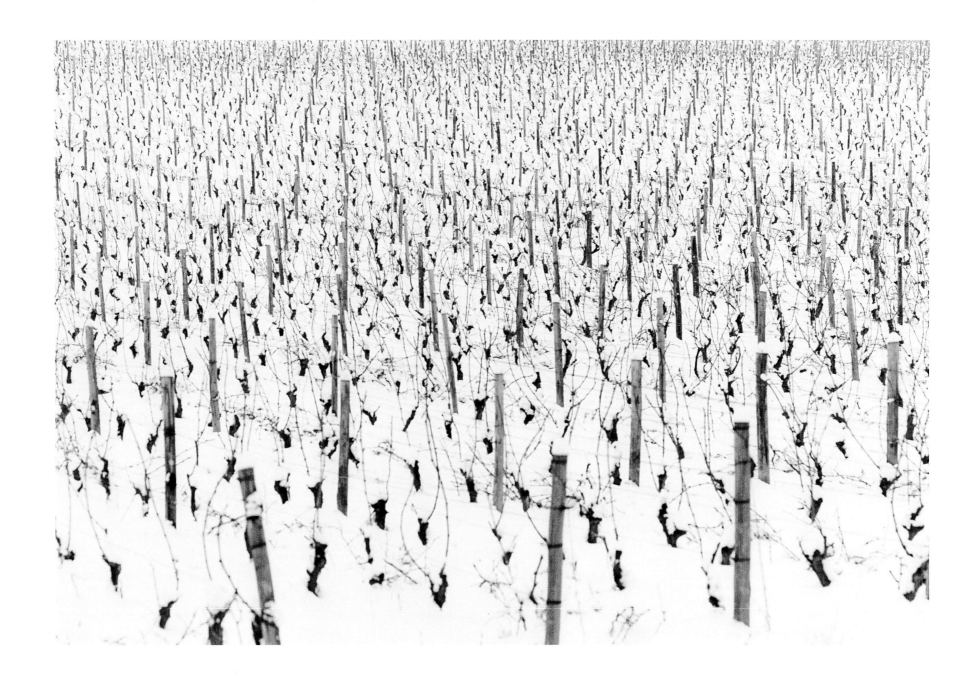

Rhône

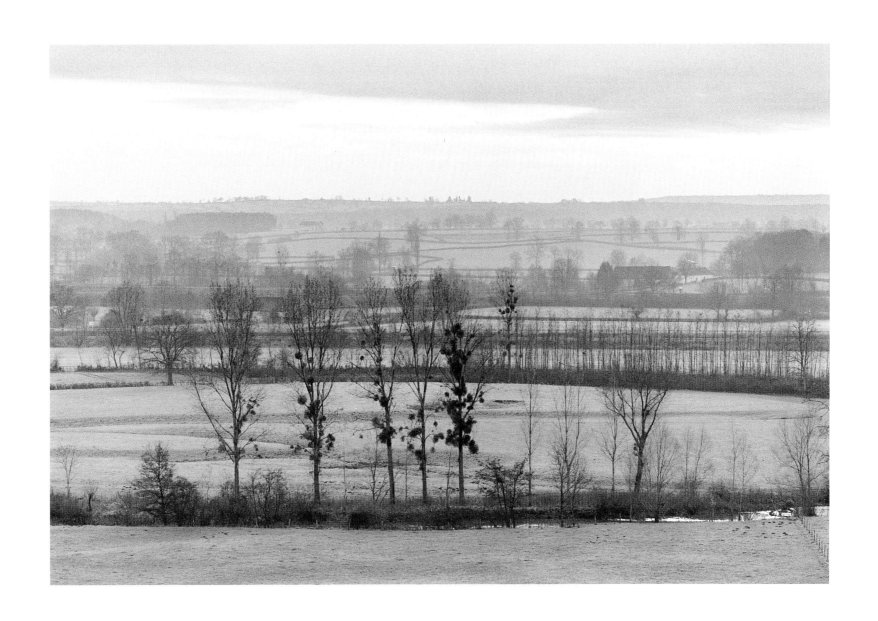

La Bourbince, Paray-le-Monial, Saône-et-Loire

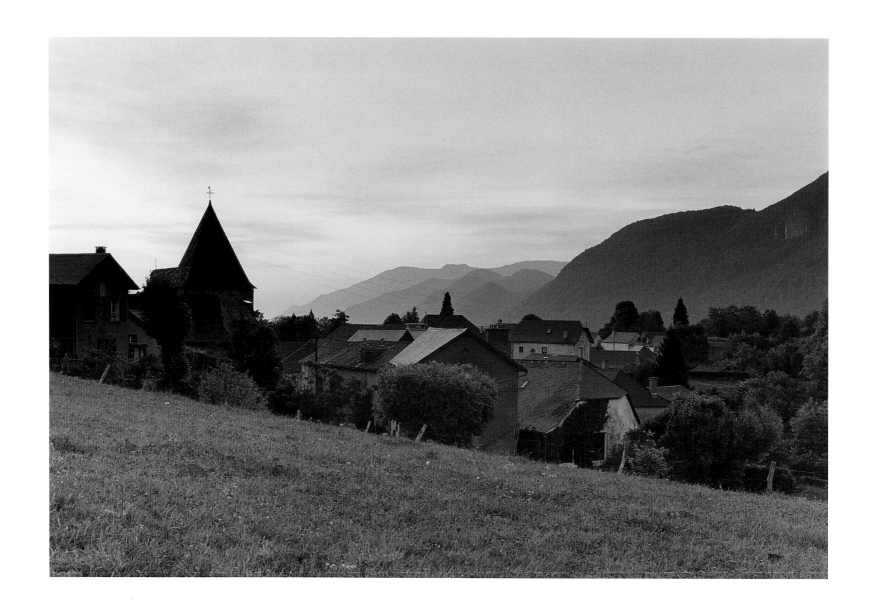

Sainte Colome, Pyrénées-Atlantique

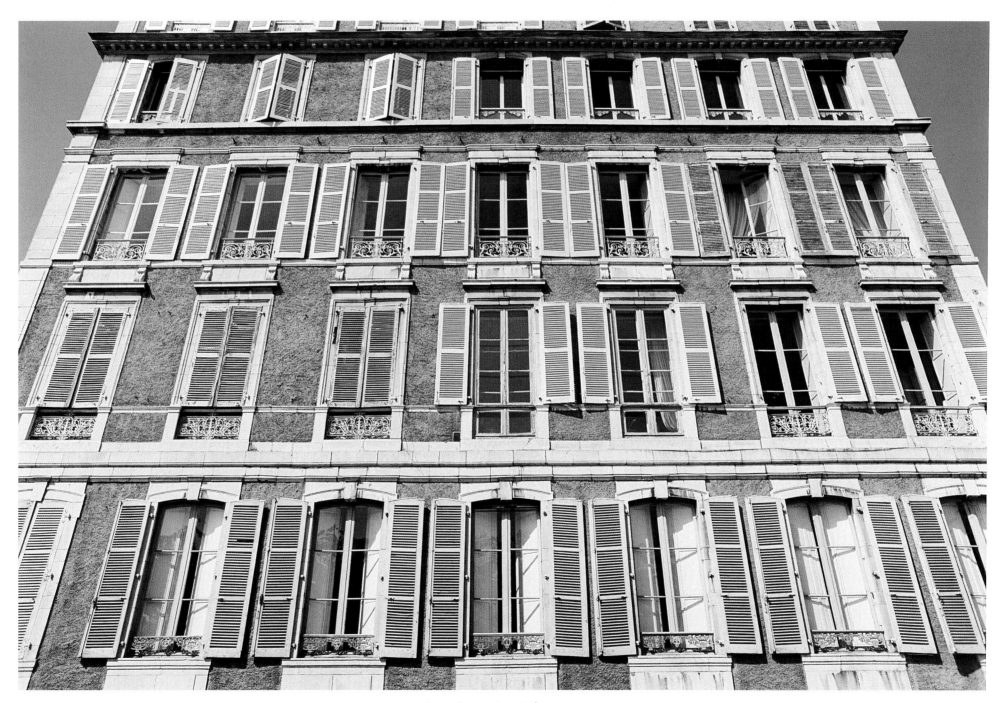

Pau, Pyrénées-Atlantique

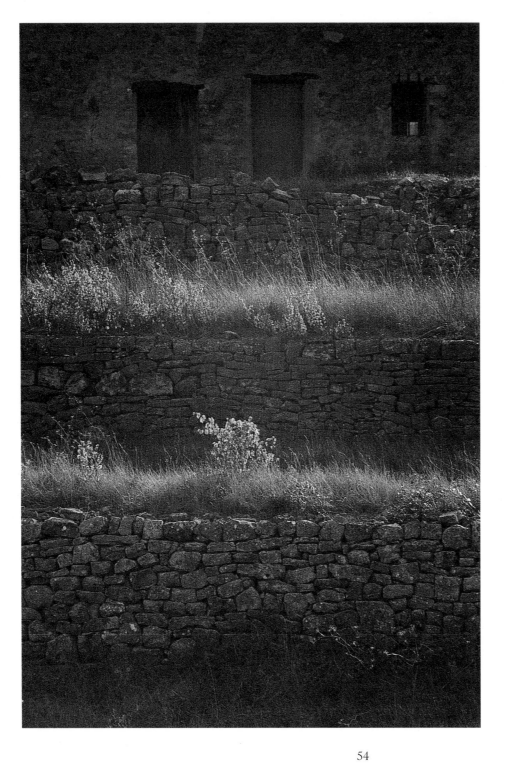

Var, Provence

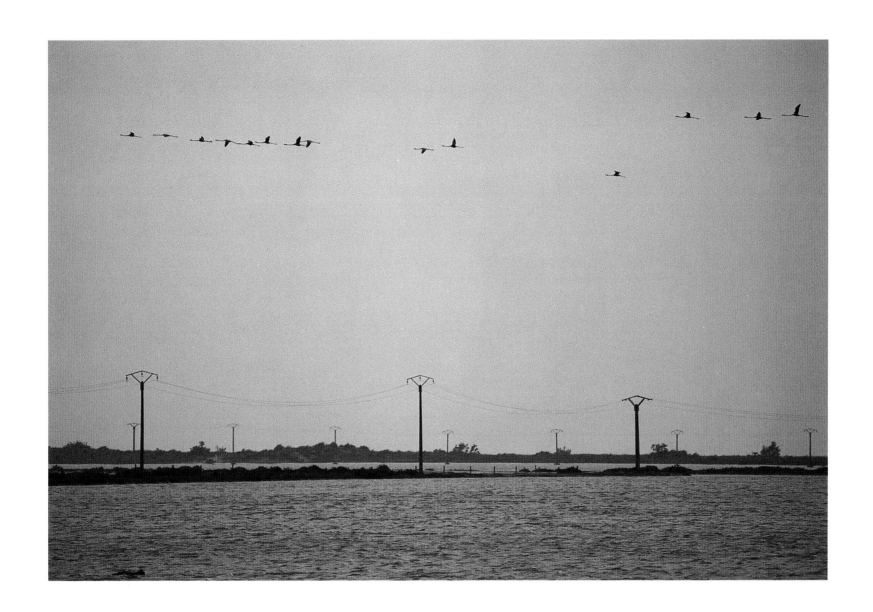

La Camargue, Bouches-du-Rhône

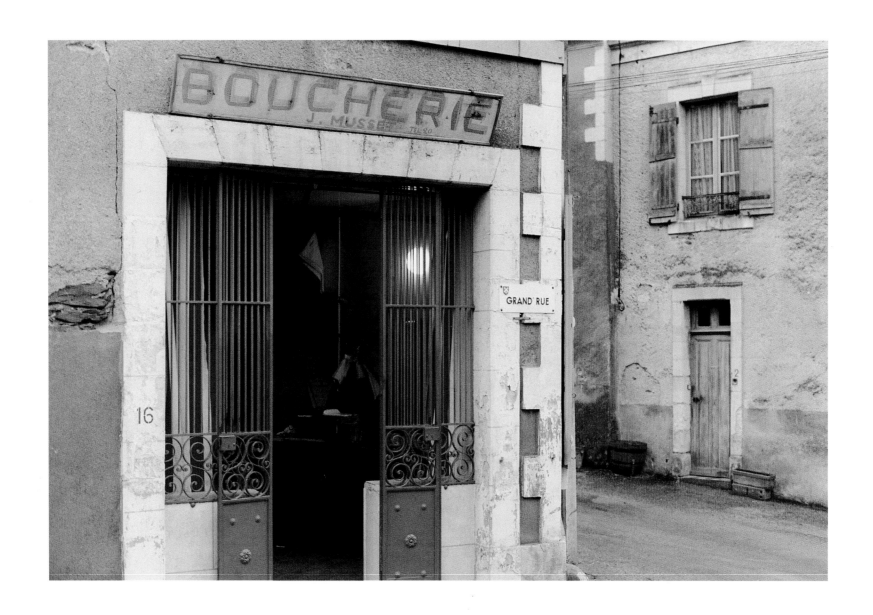

Rochefort-sur-Loire, Pays de la Loire

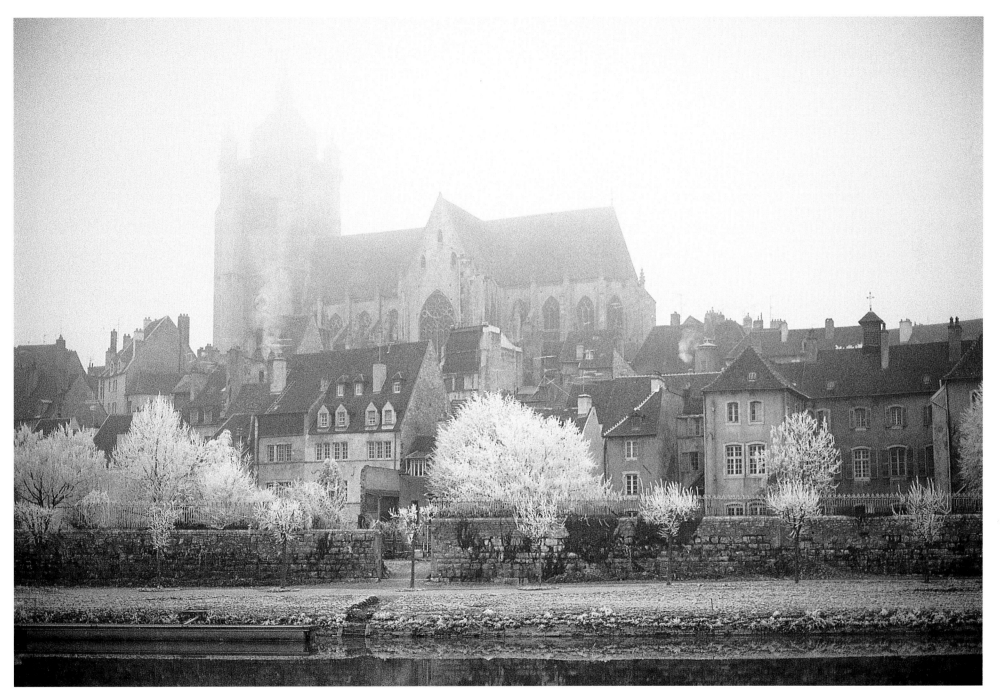

Dole, Jura

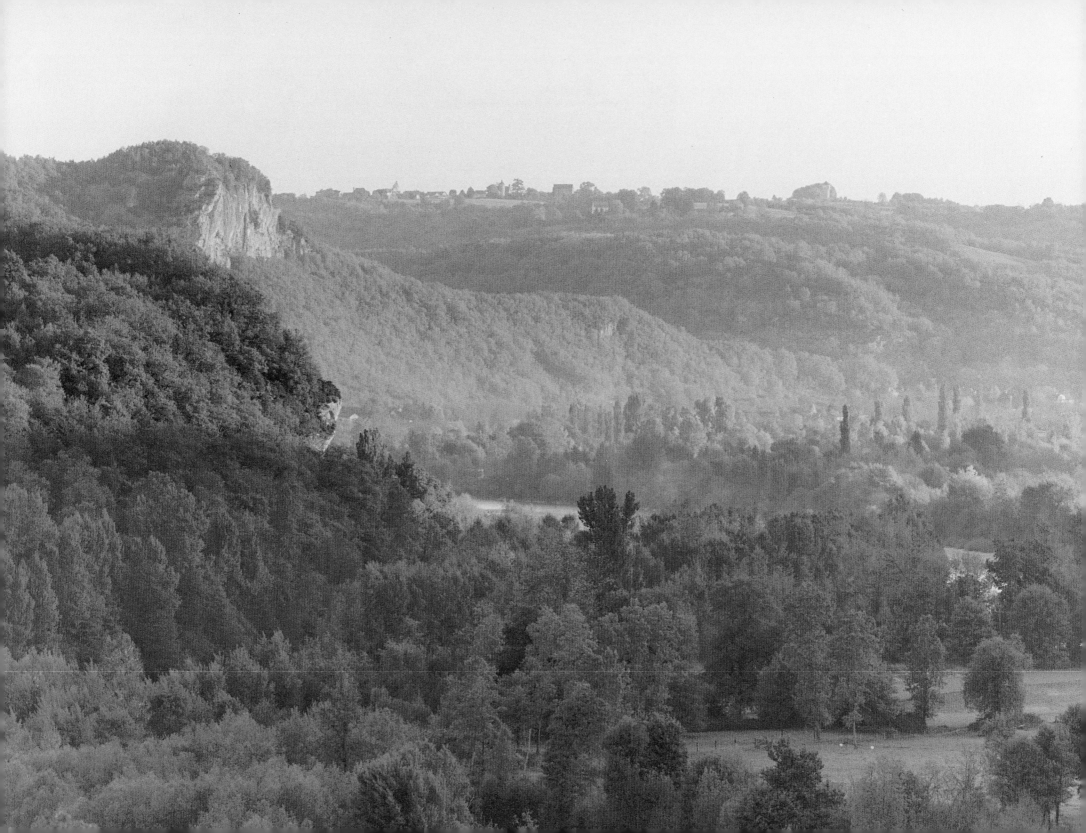

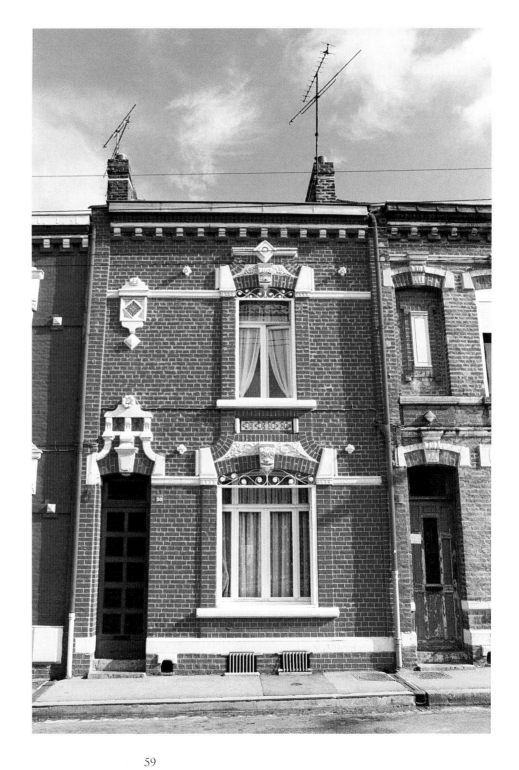

Rochers de Monges, Quercy *(opposite)*
Amiens, Picardie *(right)*

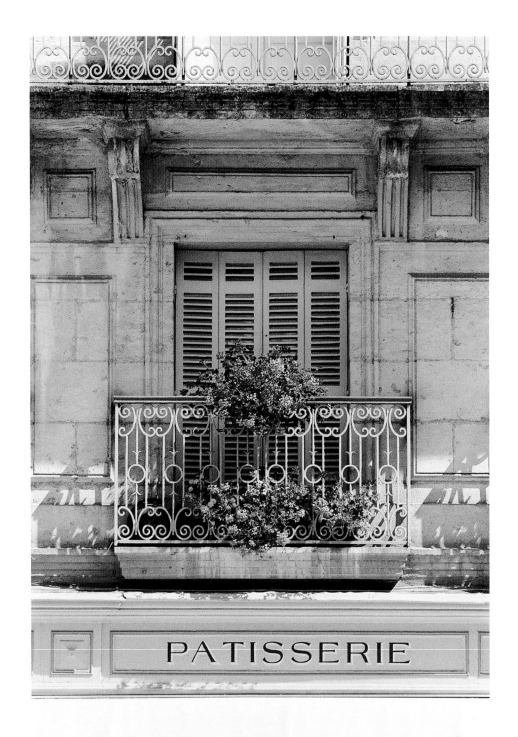

Périgueux, Dordogne

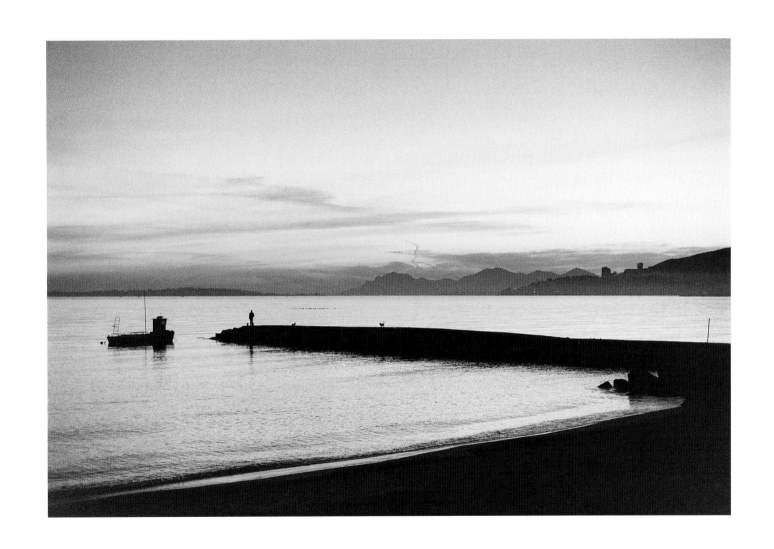

Cannes, Côte d'Azur

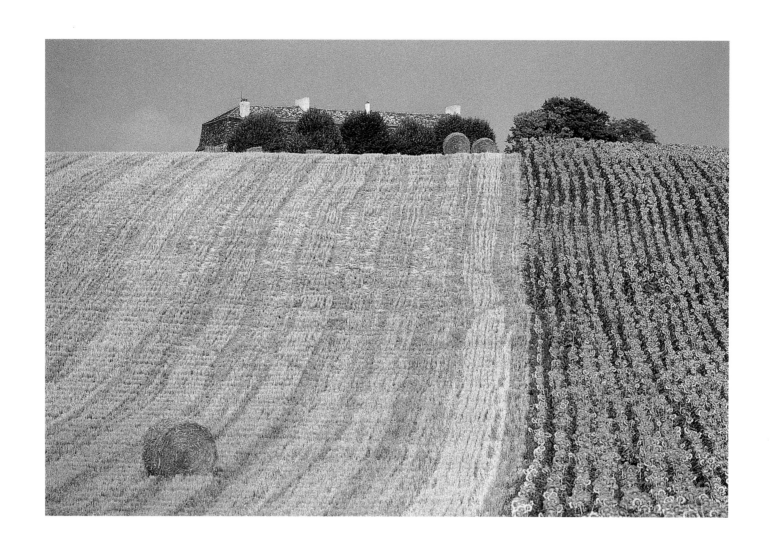

Argensac, Périgord Blanc

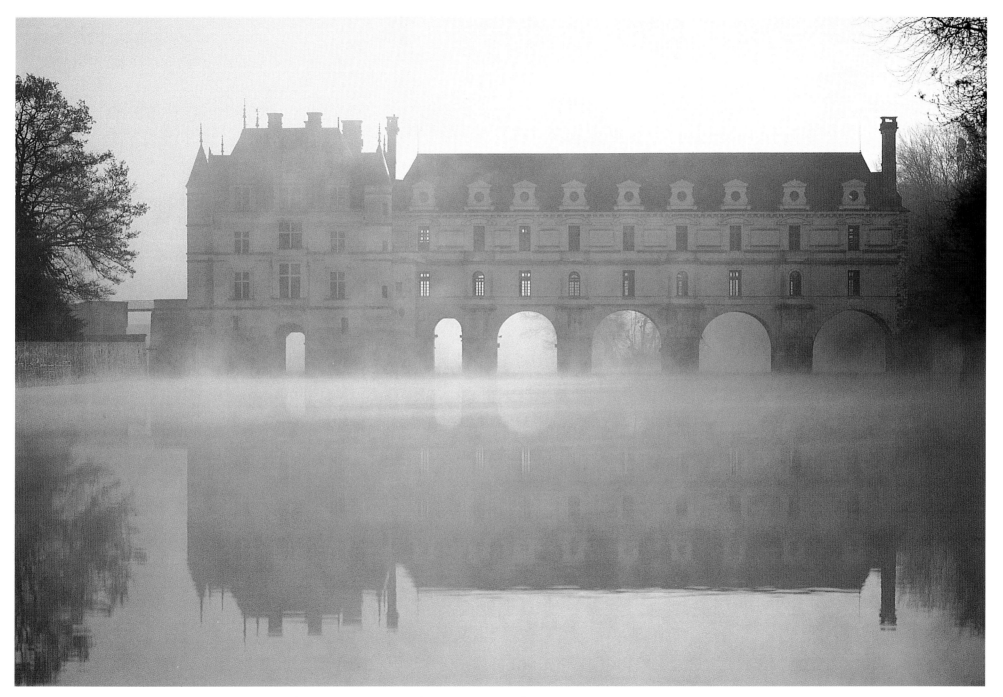

Chenonceaux, Indre-et-Loire

63

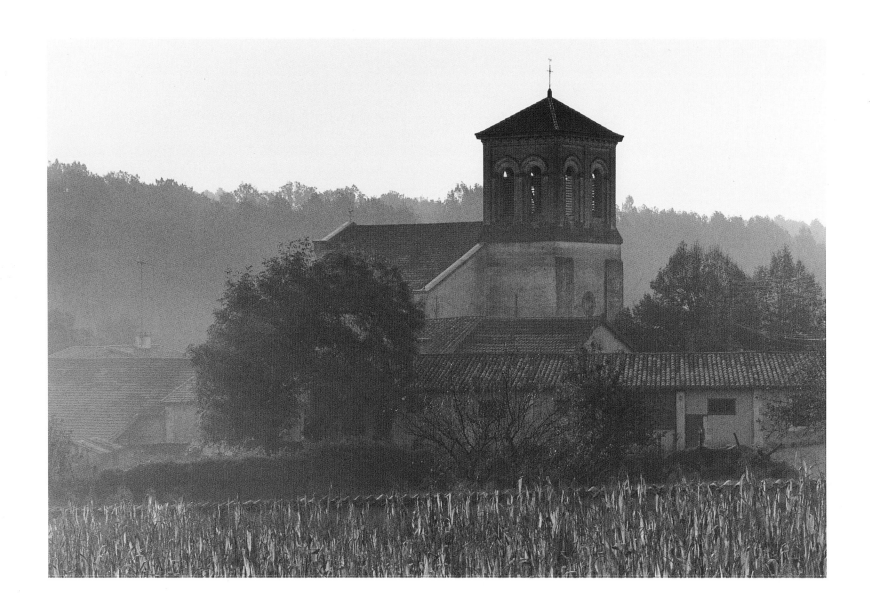

Saint Vincent-de-Connezac, Dordogne

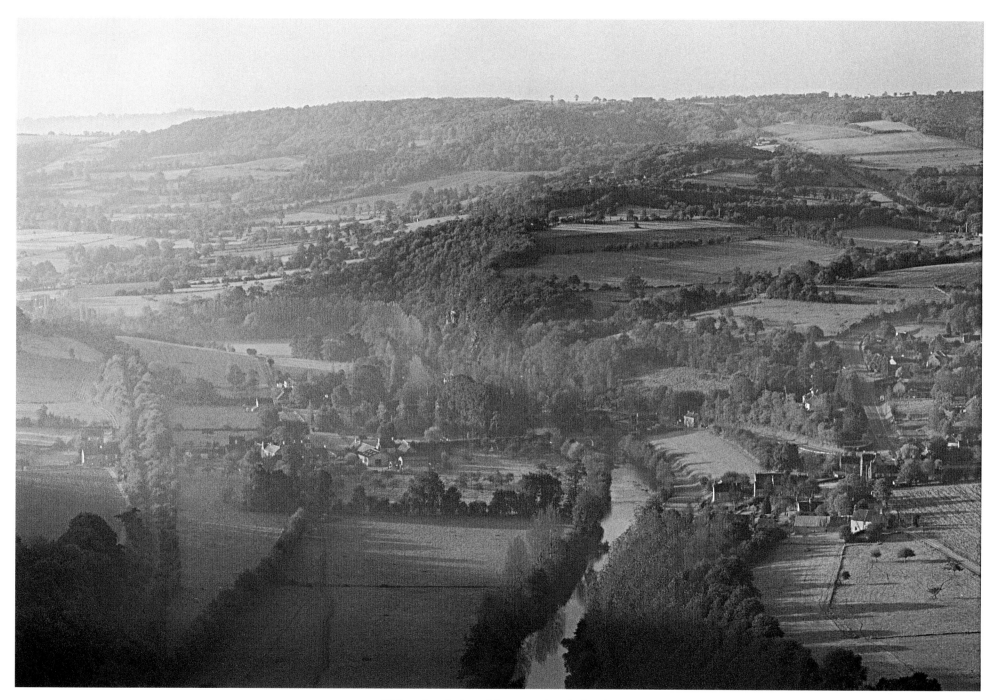

Clécy, La Suisse Normande, Calvados

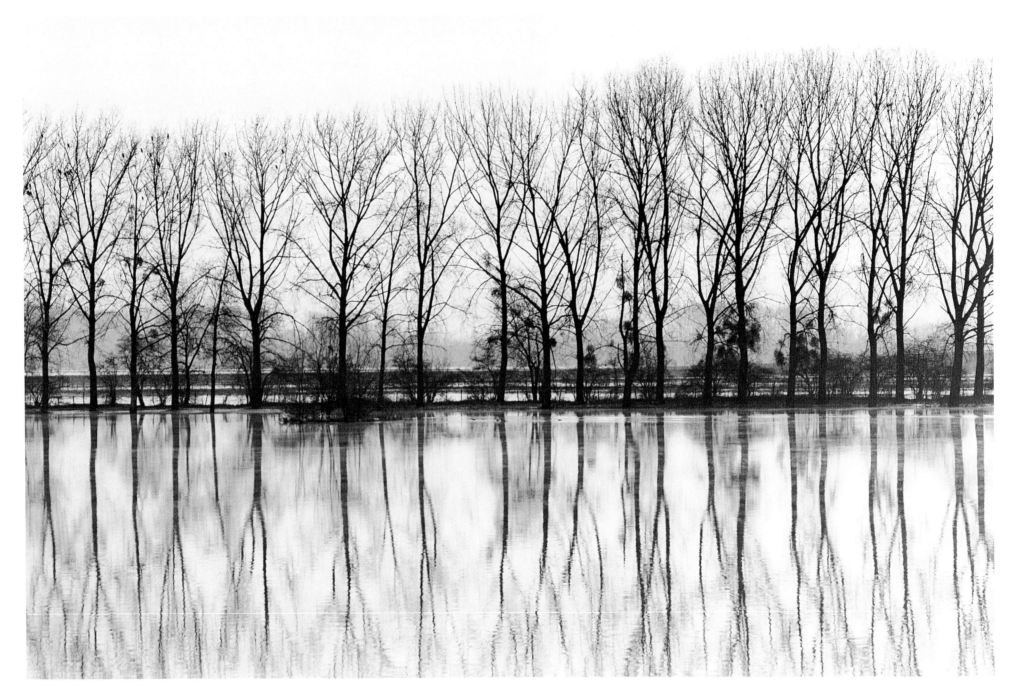

La Saône, Mâcon, Bourgogne

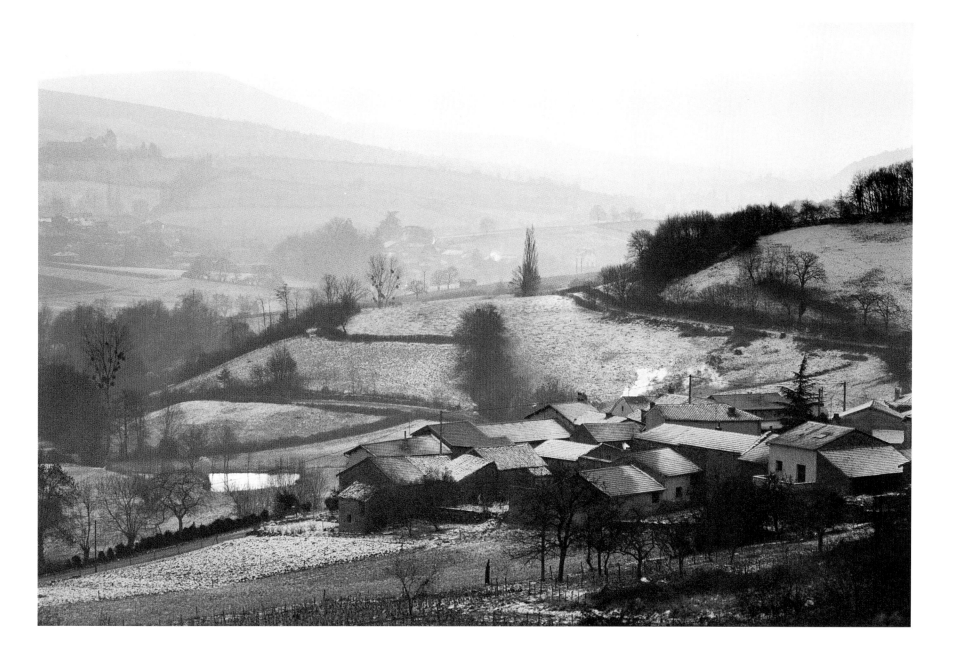

La Roche, Bourgogne

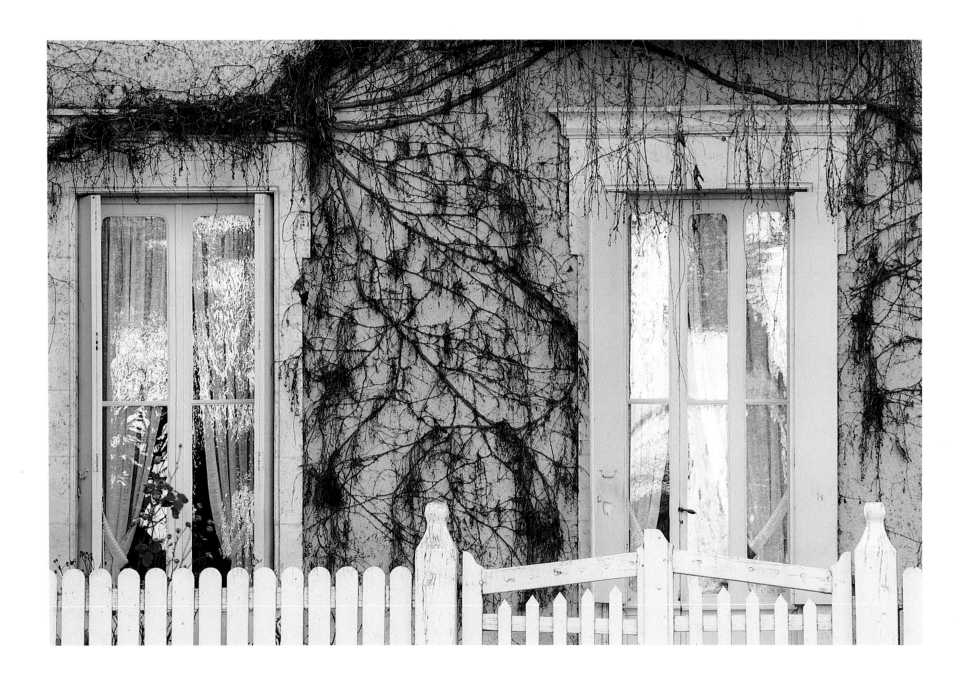

Périgord Blanc

68

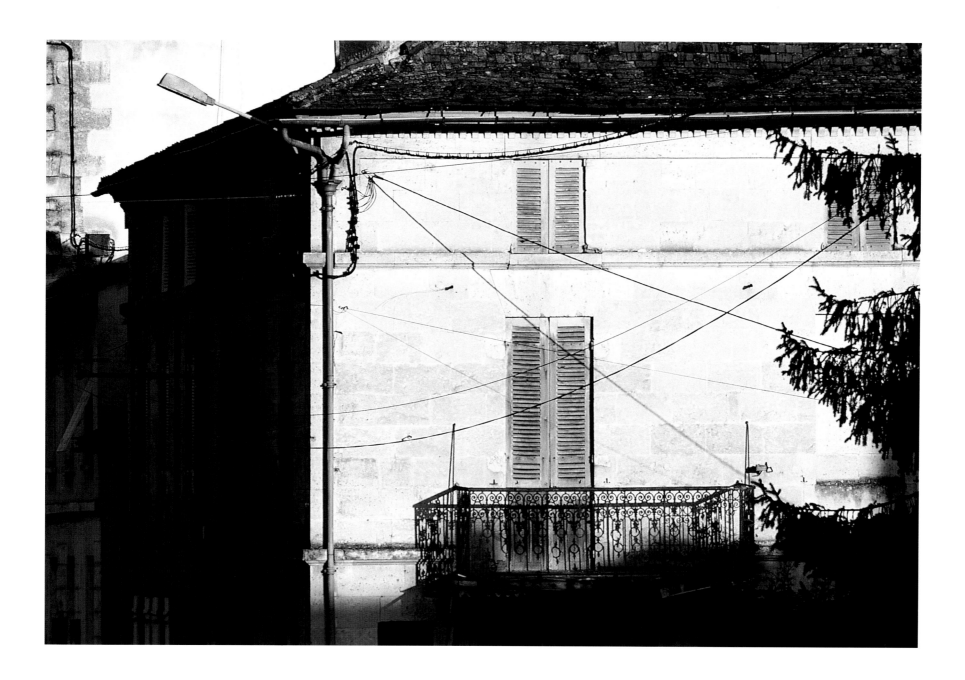

Périgord Blanc

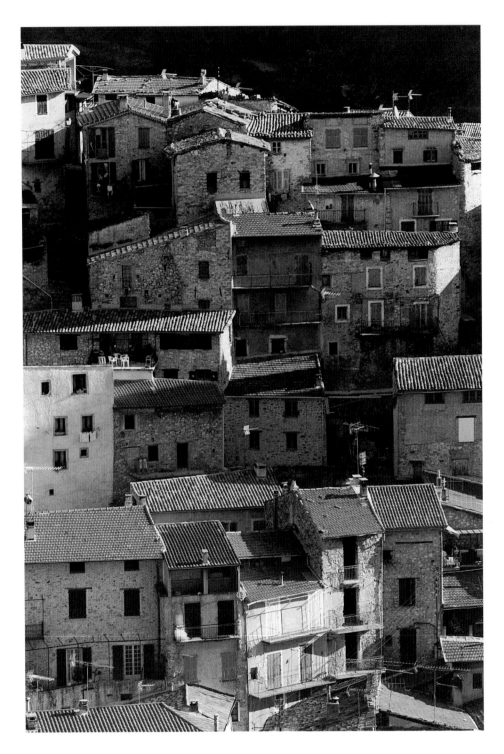

Berre-des-Alpes, Alpes-Maritimes

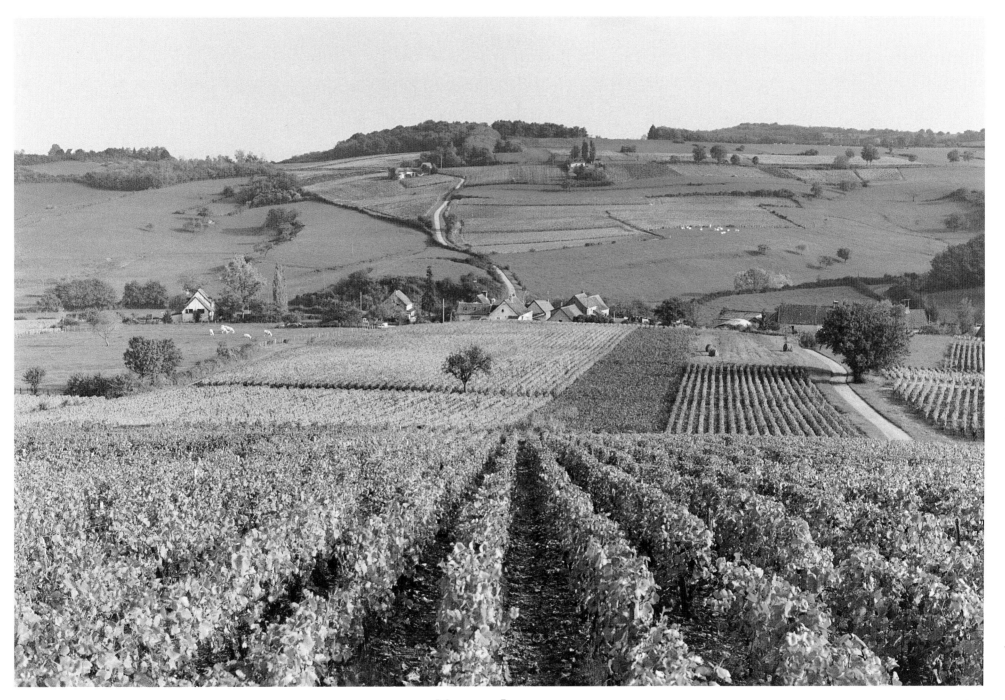

Moroges, Bourgogne

71

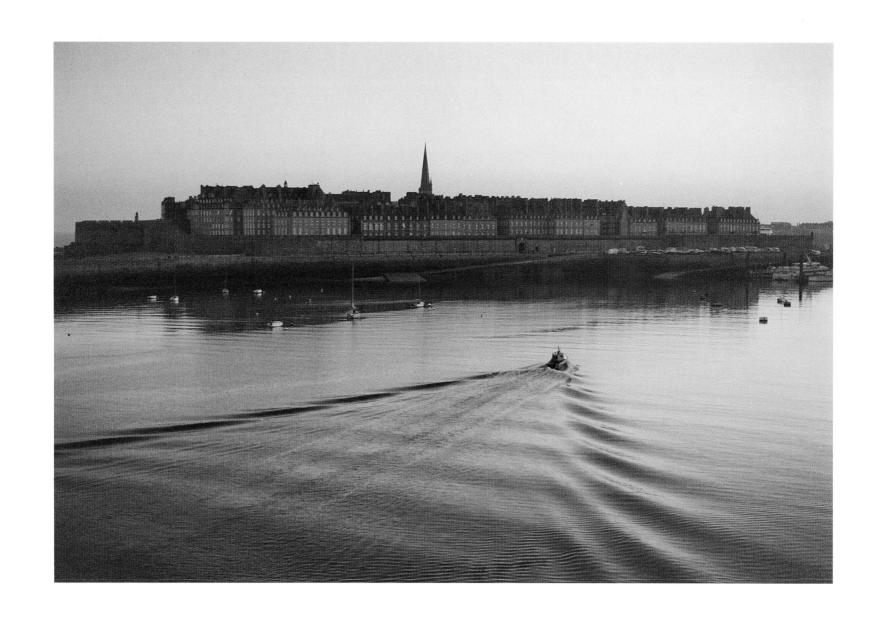

Saint Malo, Bretagne

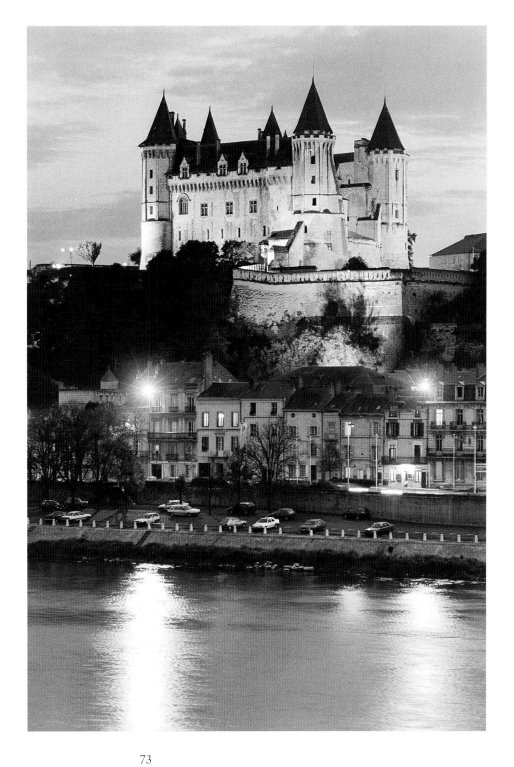

Saumur, Pays de la Loire

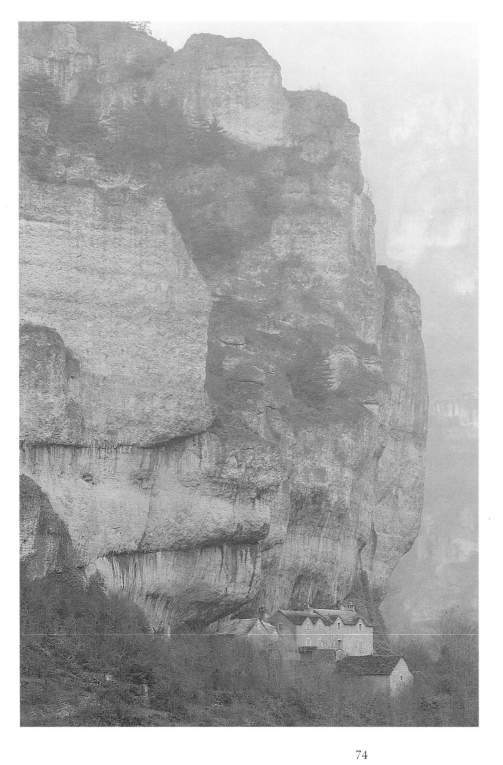

Gorges du Tarn, Lozère

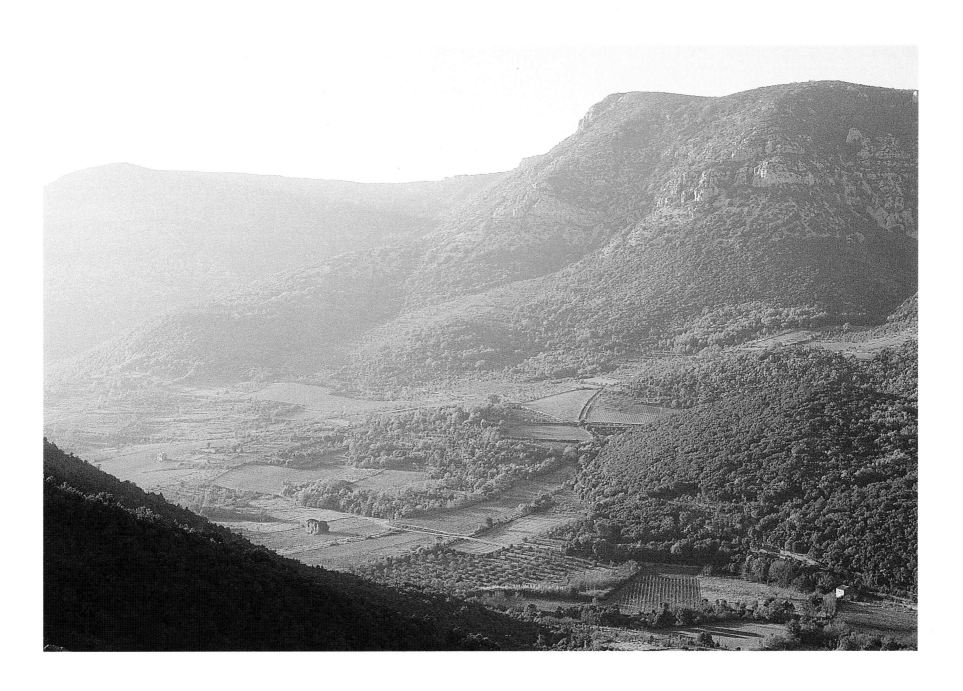

Peyre Martine, Hérault

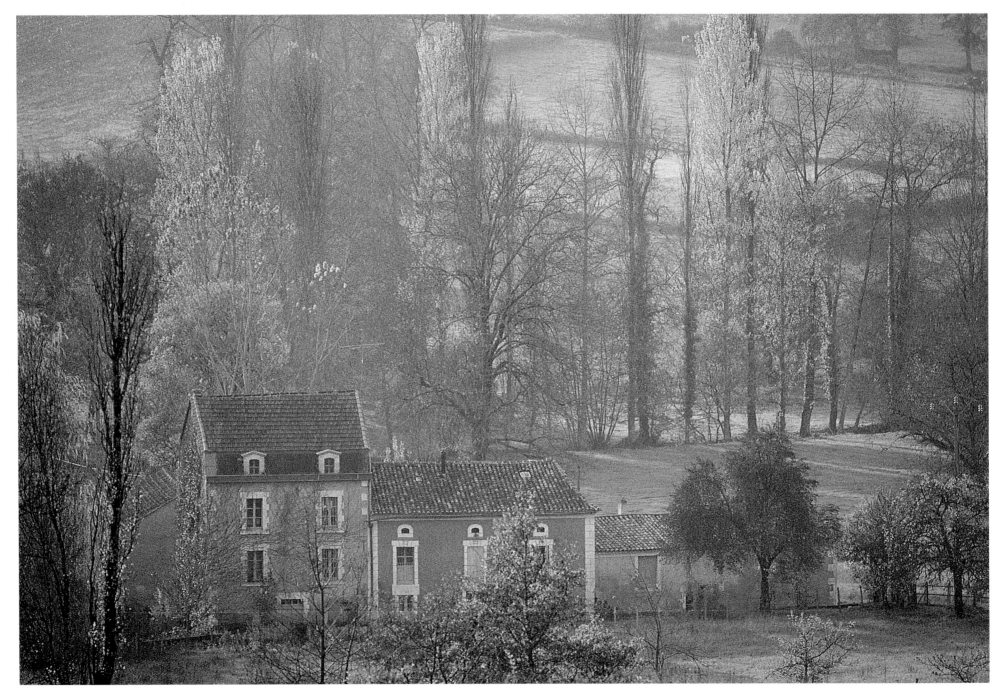

La Grande Clavelie, Périgord Blanc

76

Côte Vermeille, Pyrénées-Orientales

77

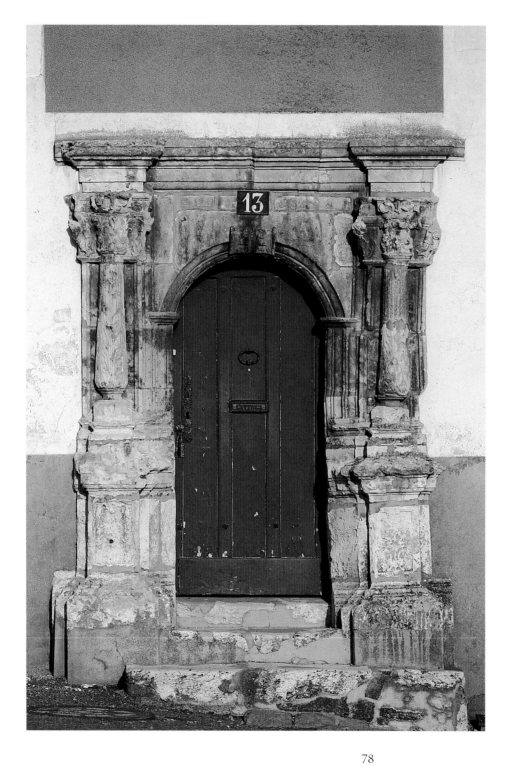

Châteaudun, Eure-et-Loir

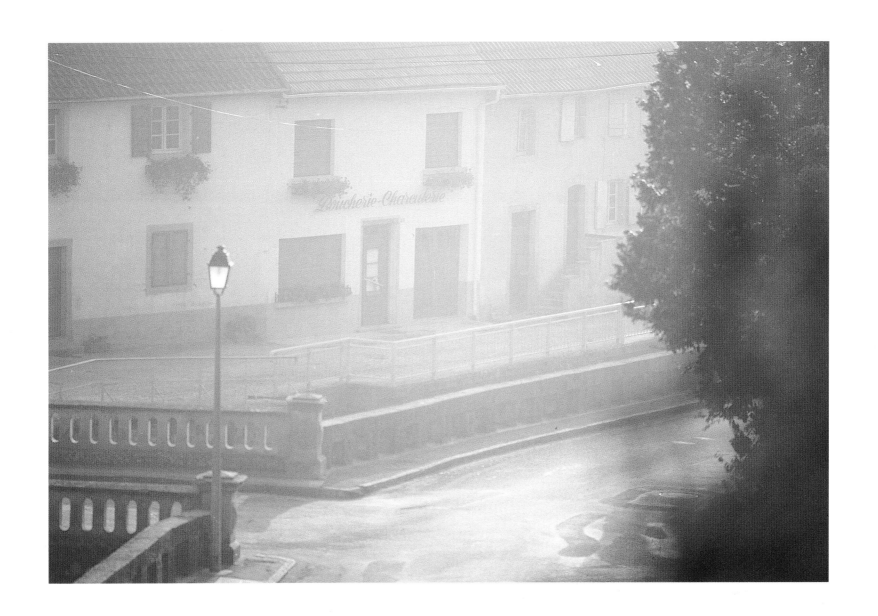

Oberhaslach, Alsace

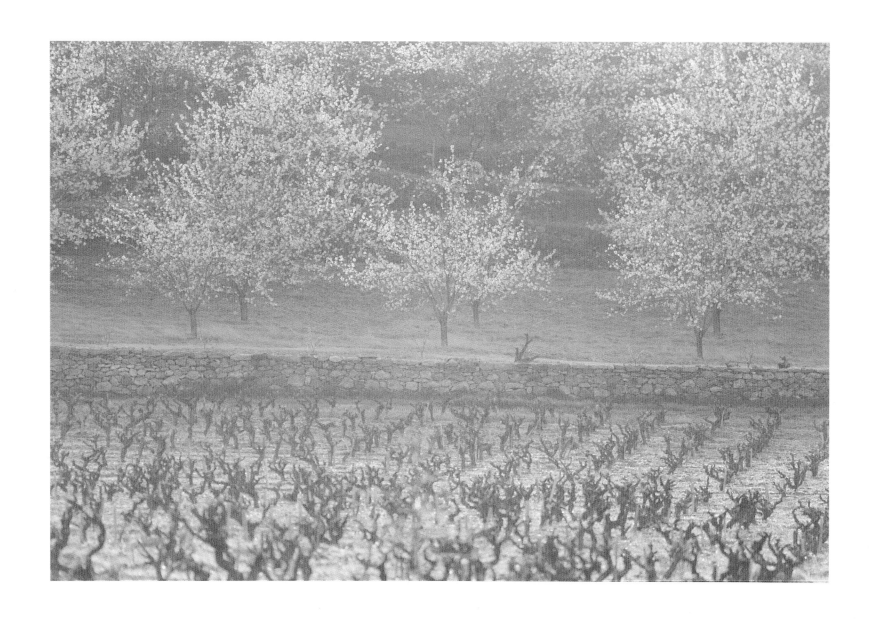

Roussillon *(above)*
Le Mont-Saint-Michel, Basse-Normandie *(opposite)*

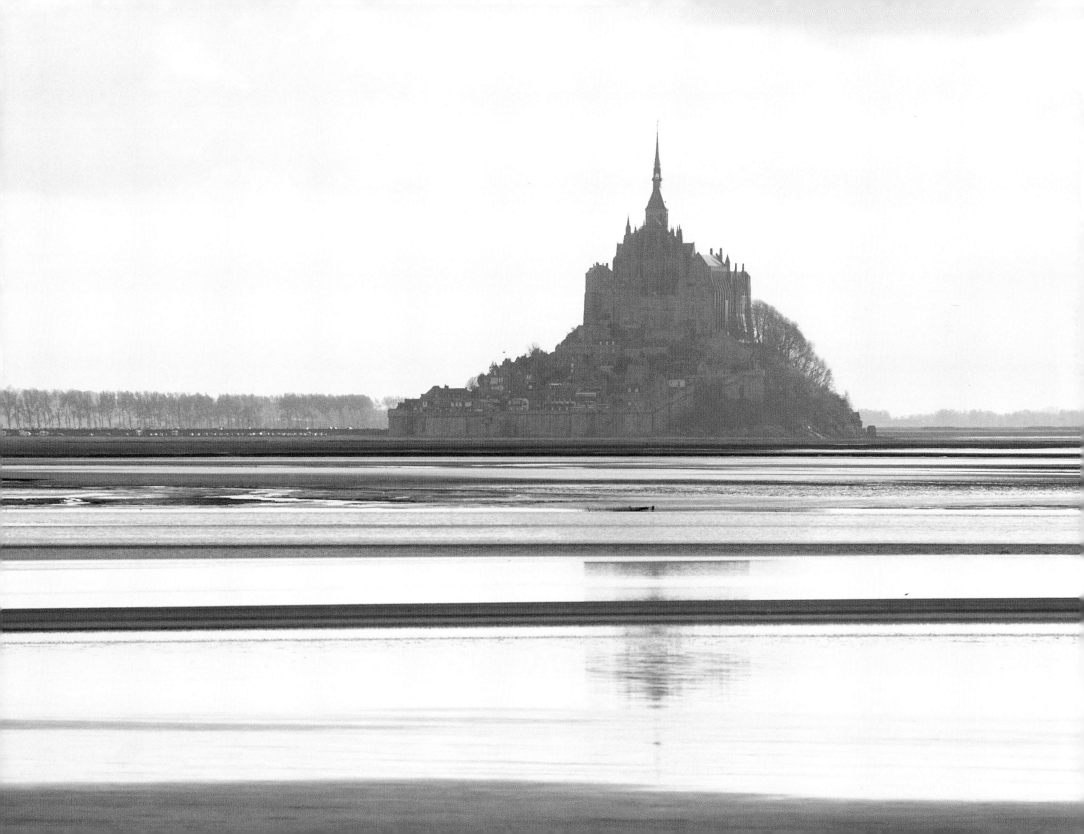

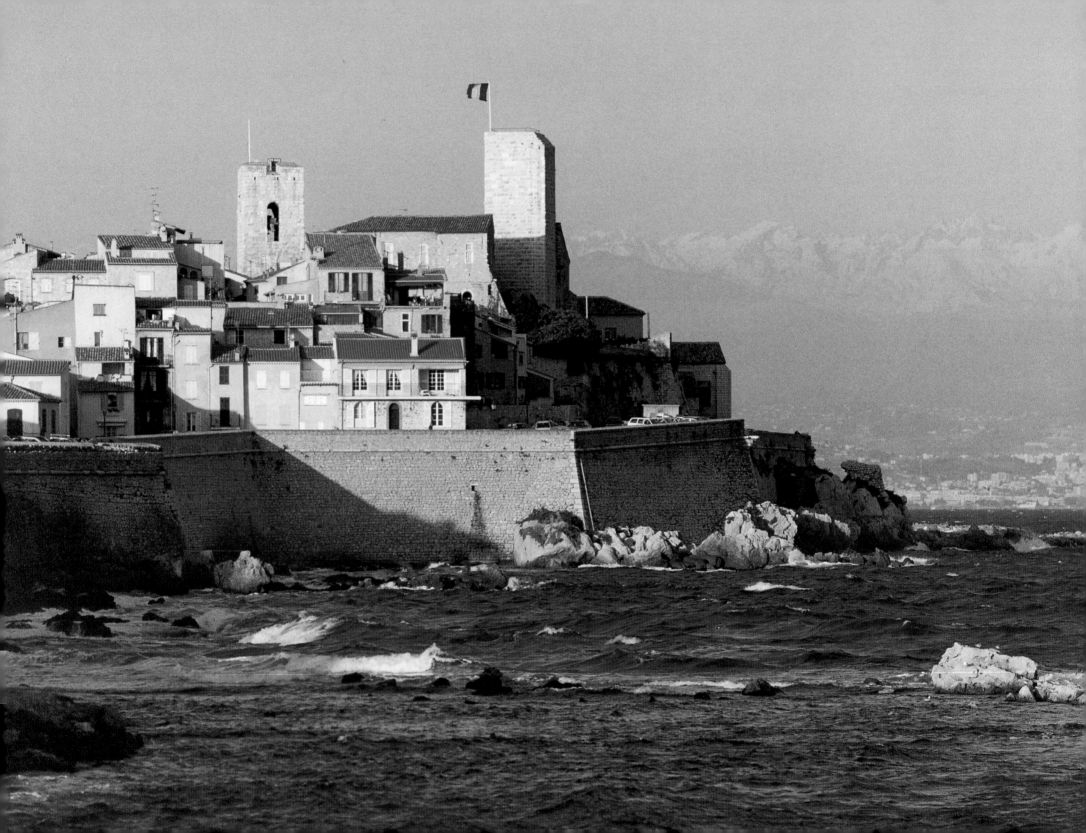

Antibes, Côte d'Azur *(opposite)*
Saussignac, Dordogne *(above)*

83

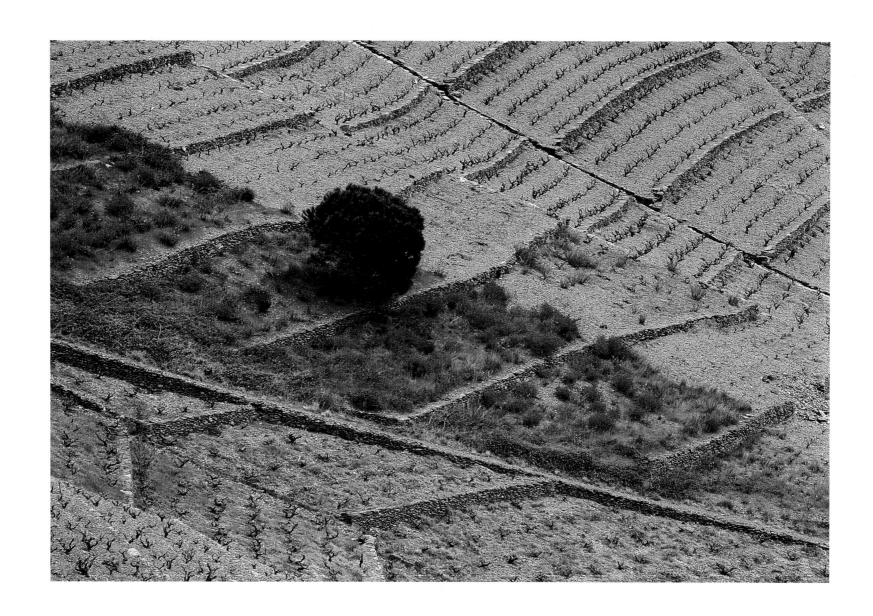

Puig de las Daynes, Pyrénées-Orientales

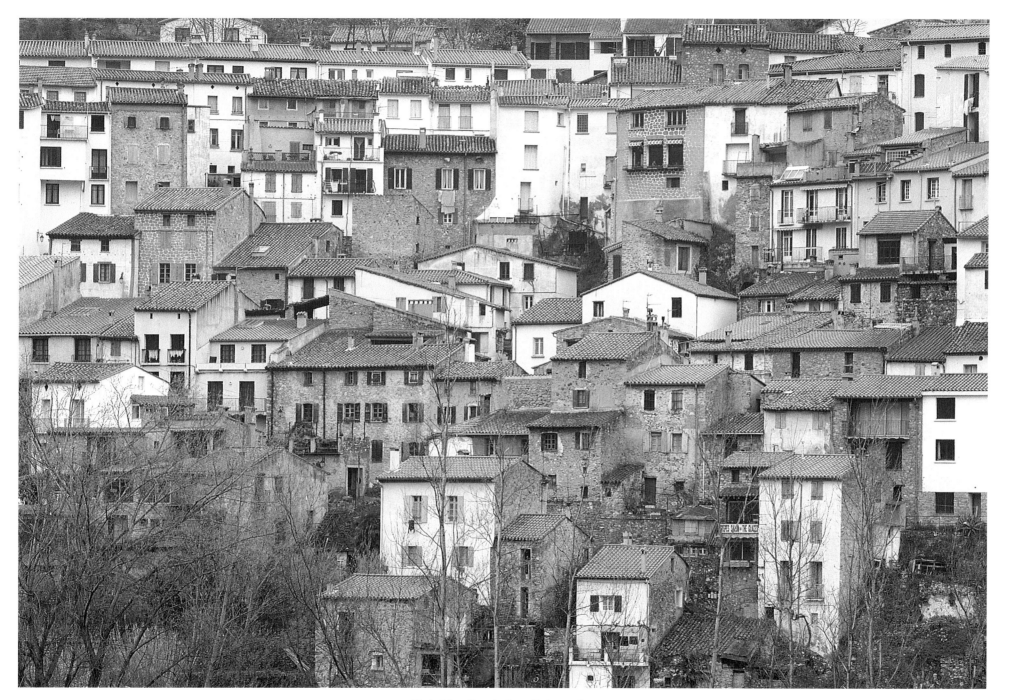

Palalda, Pyrénées-Orientales

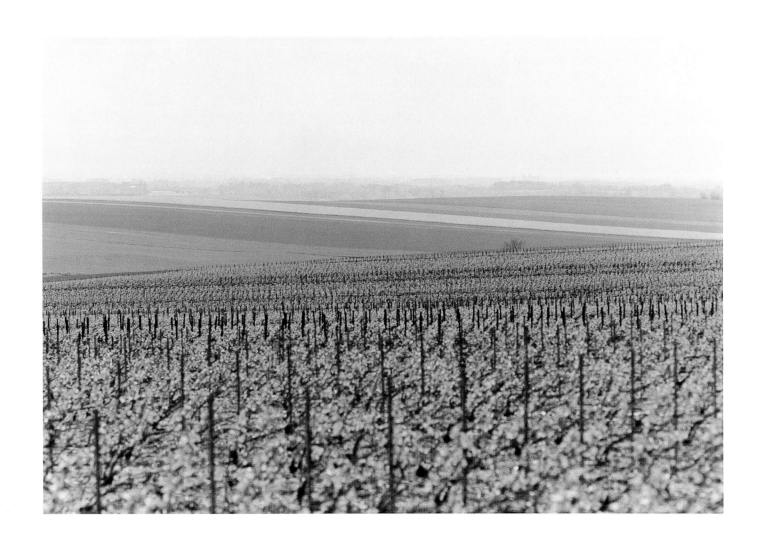

Ambonnay, Champagne

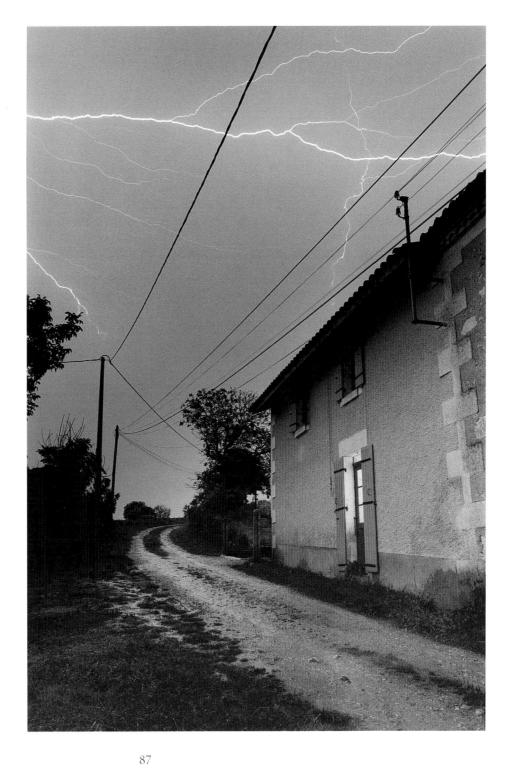

Périgord Blanc

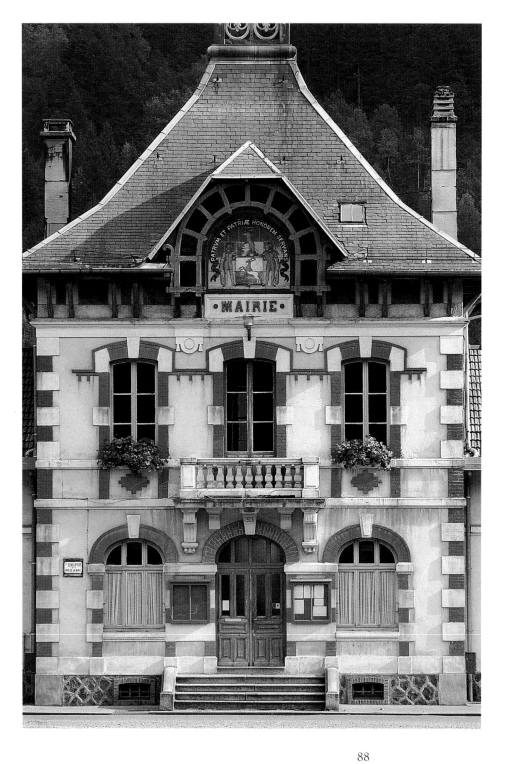

Servance, Haute-Saône

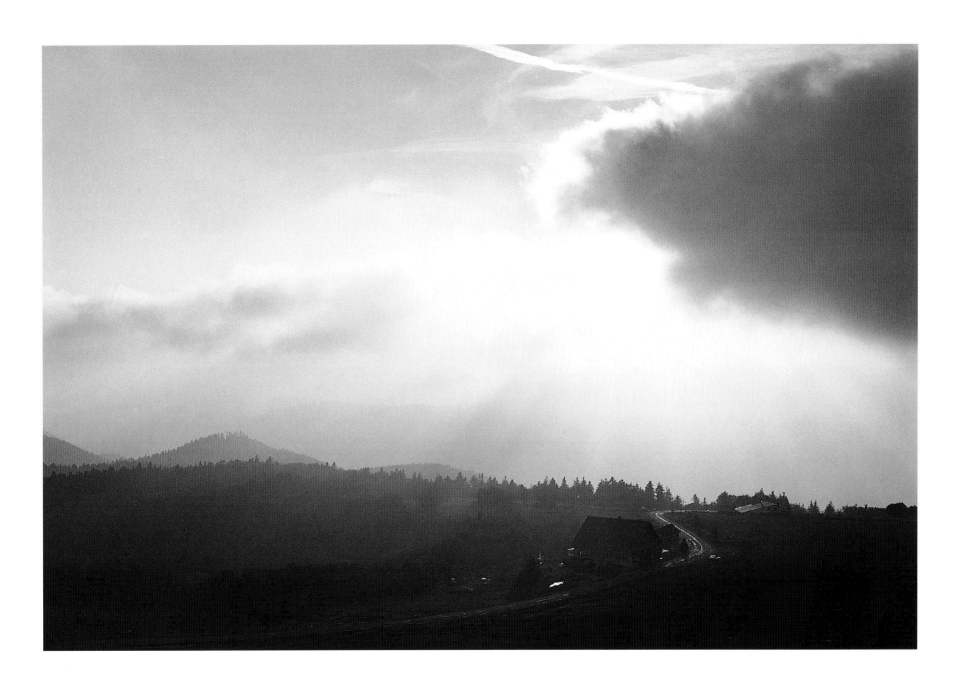

Ballon de Servance, Haute-Saône

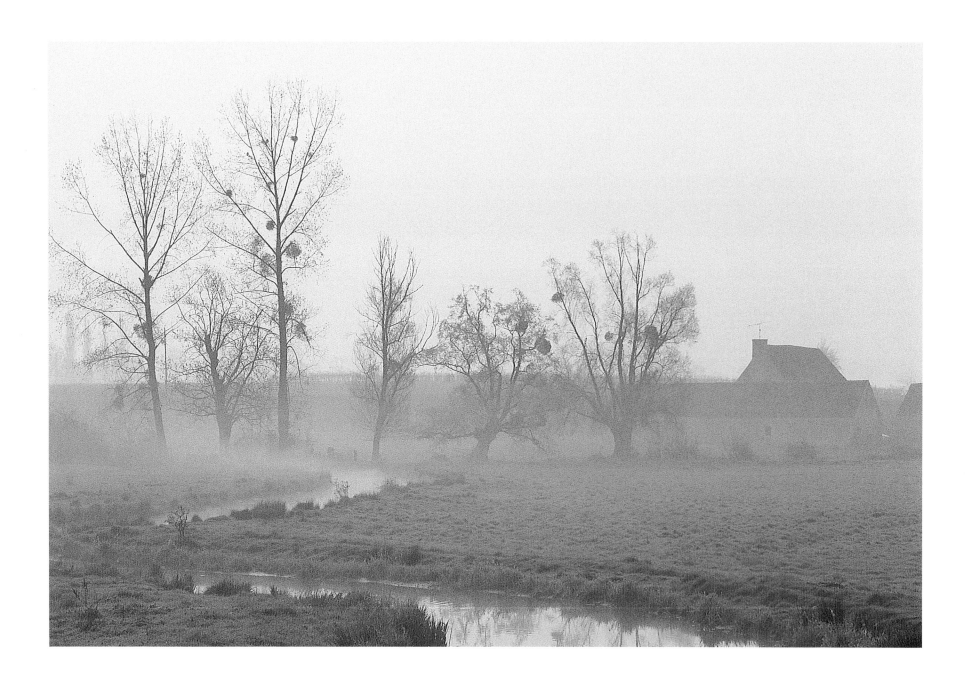

Le Tronchet, Basse-Normandie

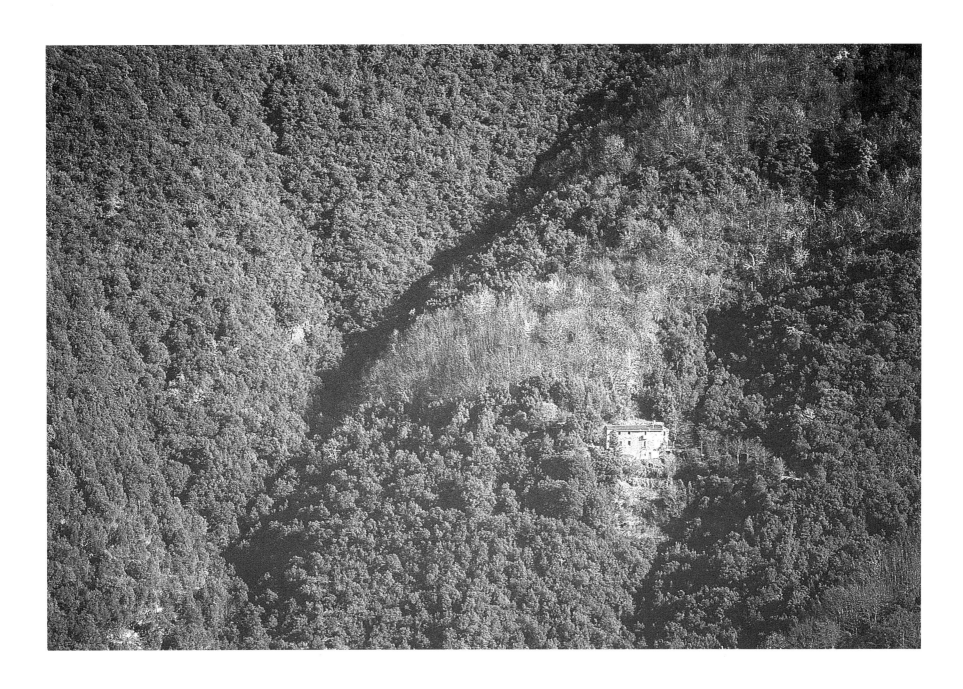

Saint-Julien-de-la-Nef, Gard

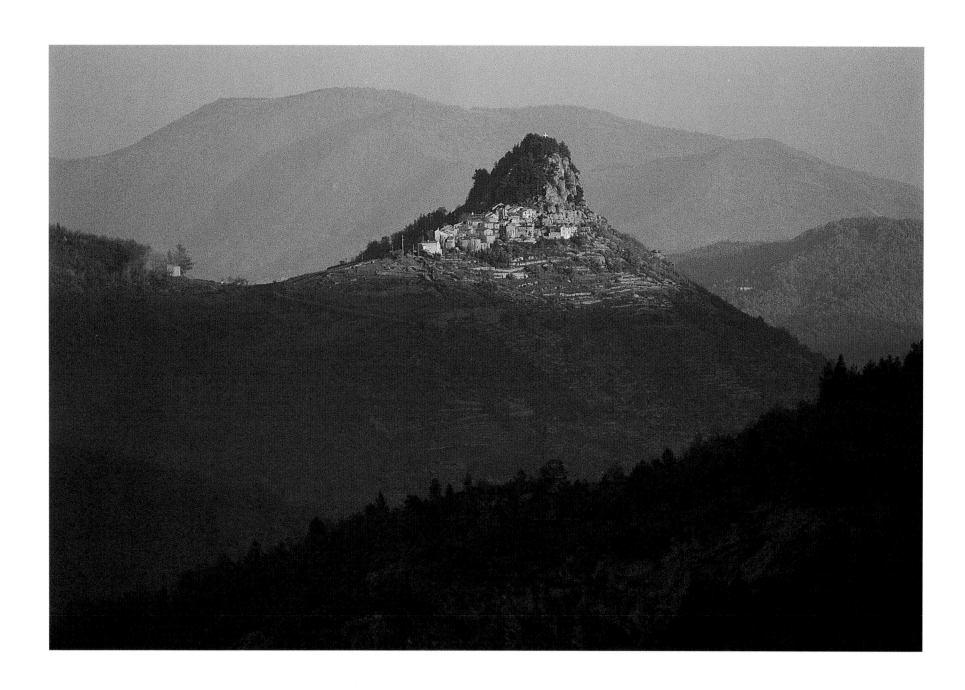

Les Aspres, Pyrénées-Orientales

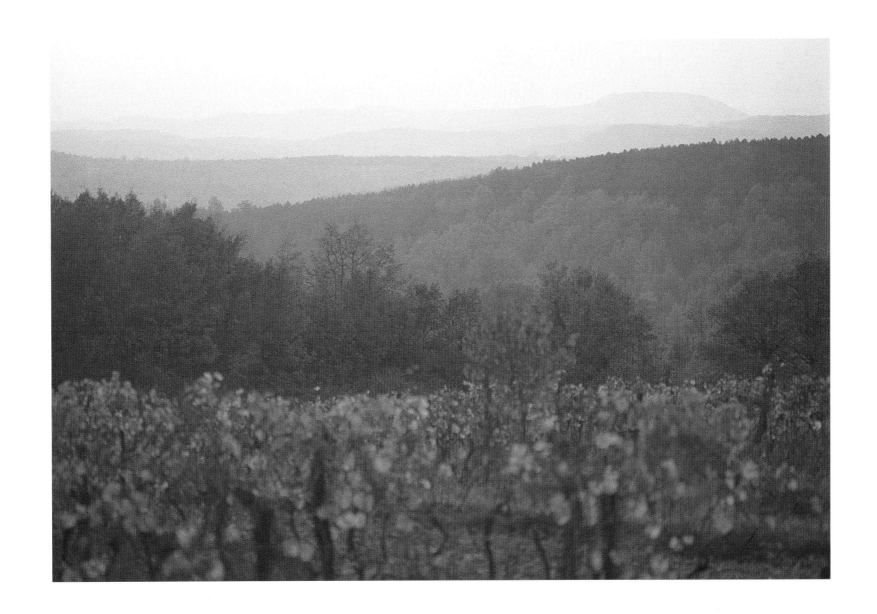

Nadaillac-de-Rouge, Quercy

Montmelard, Bourgogne

94

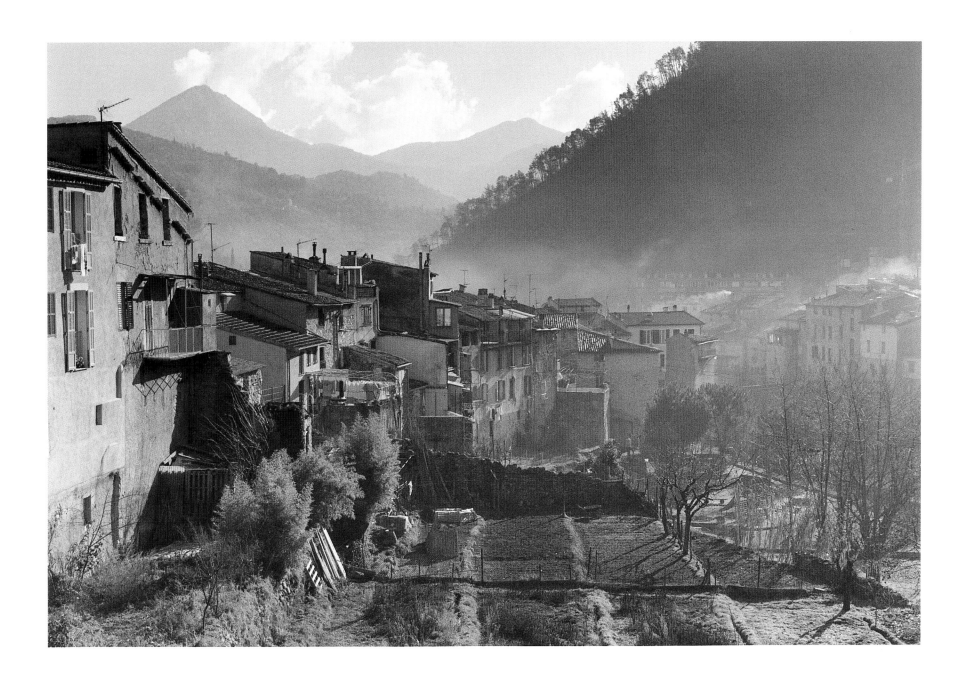

L'Escarène, Alpes-Maritimes

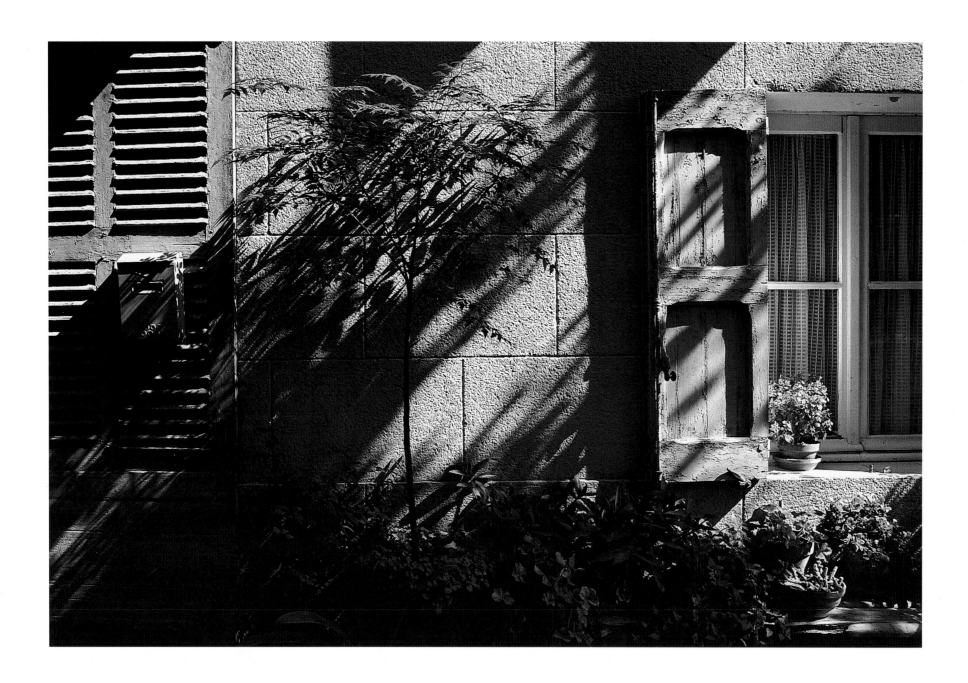

Barjols, Provence

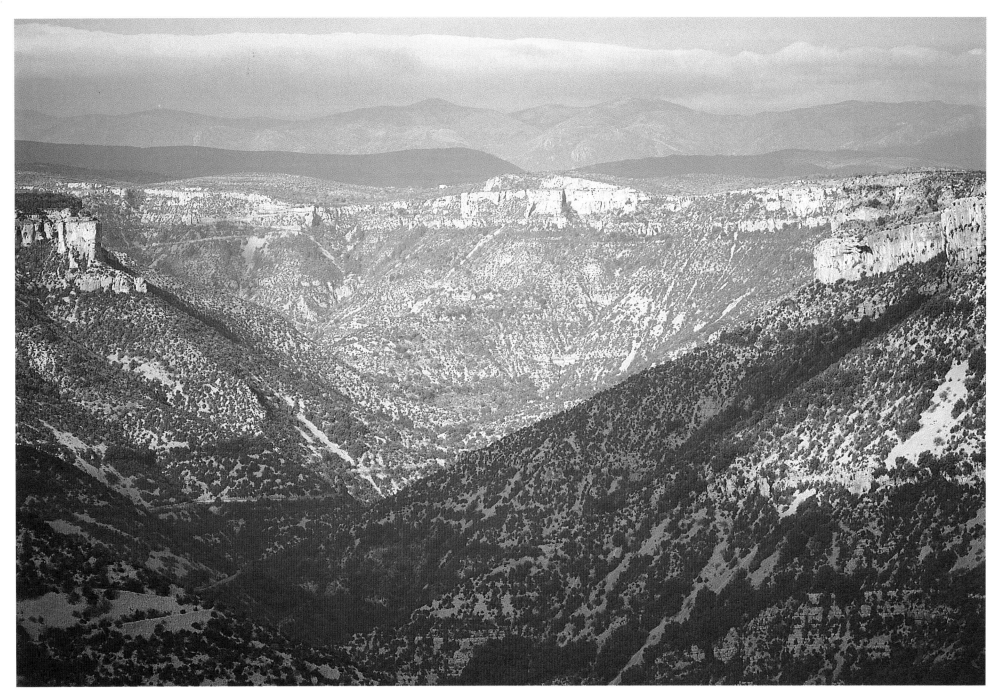

Gorges de la Vis, Languedoc

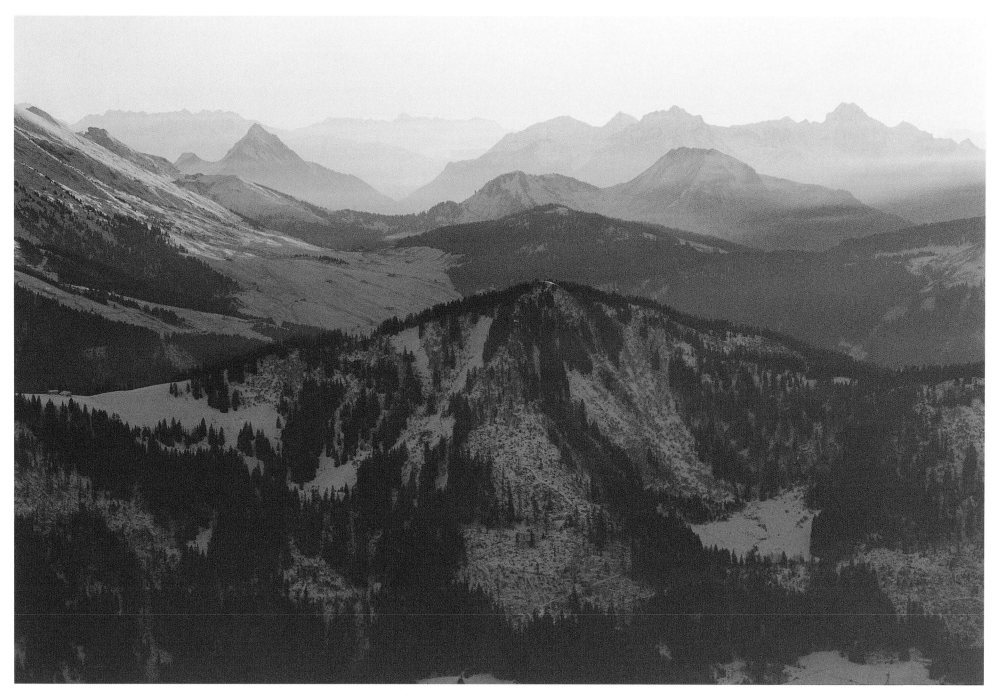

Chaîne des Aravis, Haute-Savoie

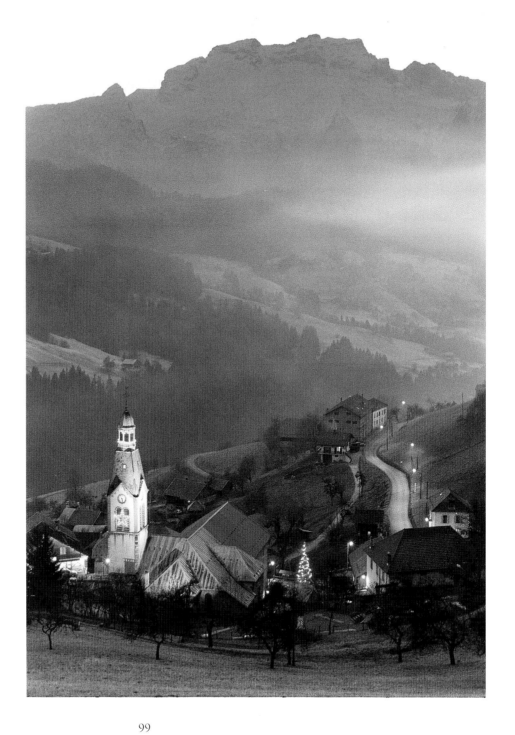

Manigod, Haute-Savoie

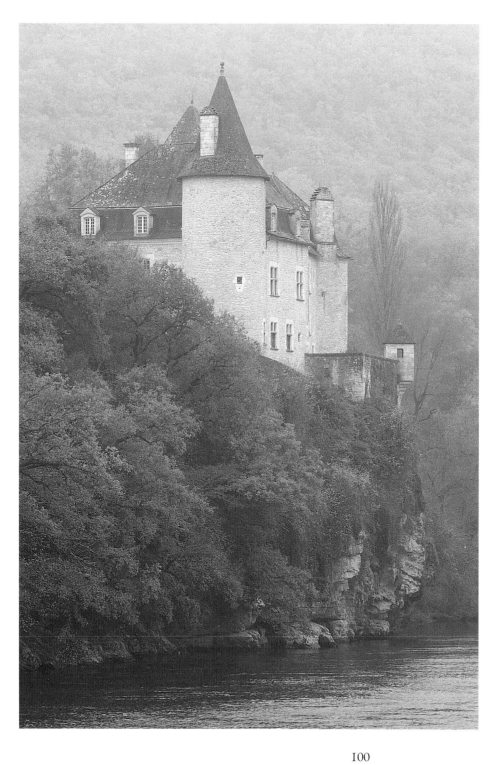

Château de la Treyne, Quercy

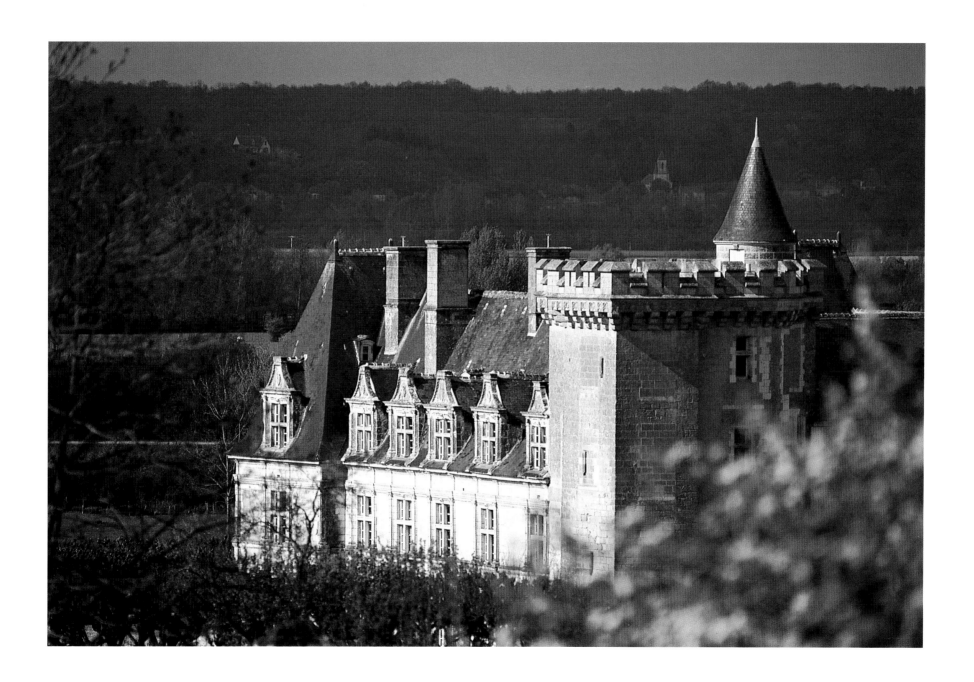

Villandry, Indre-et-Loire

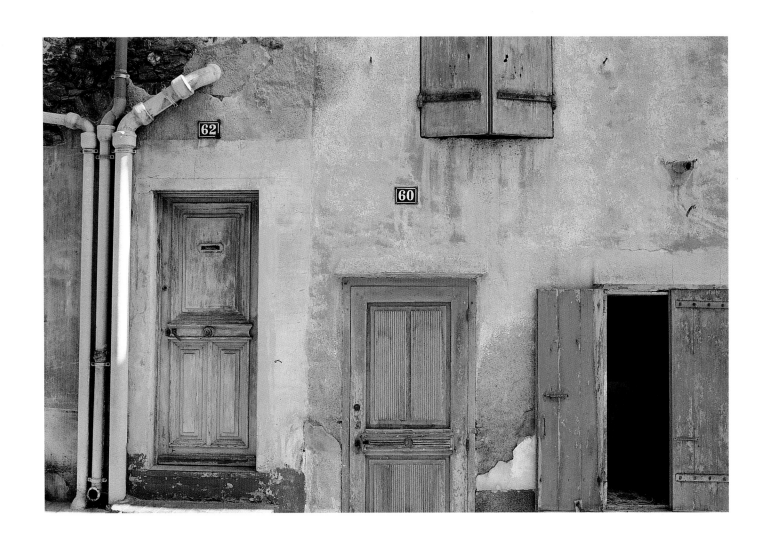

Port-Vendres, Pyrénées-Orientales

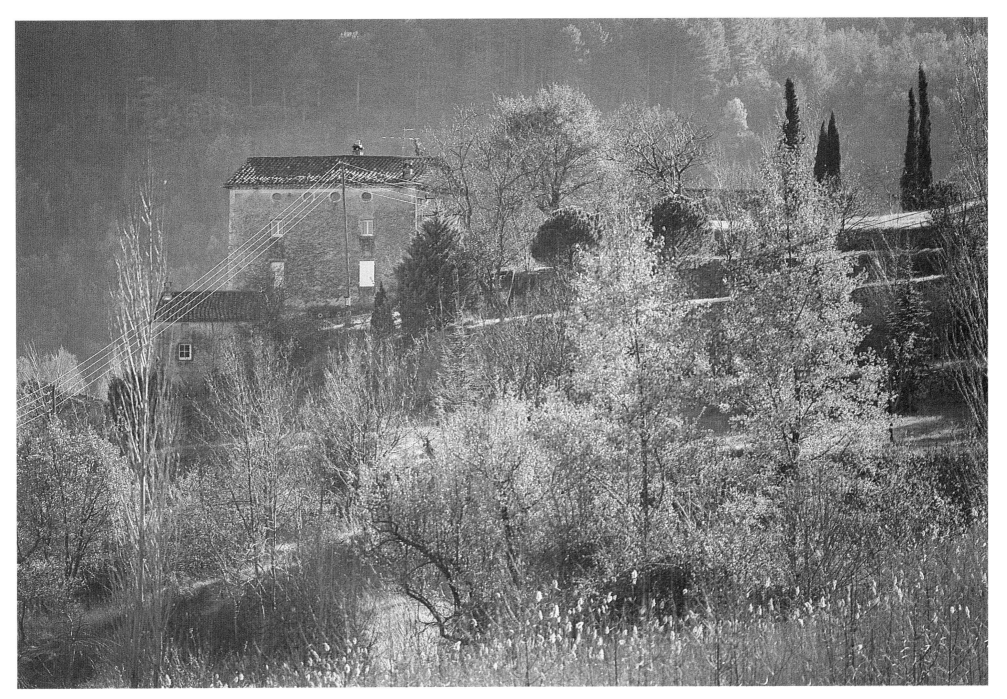

Soutayrol, Languedoc

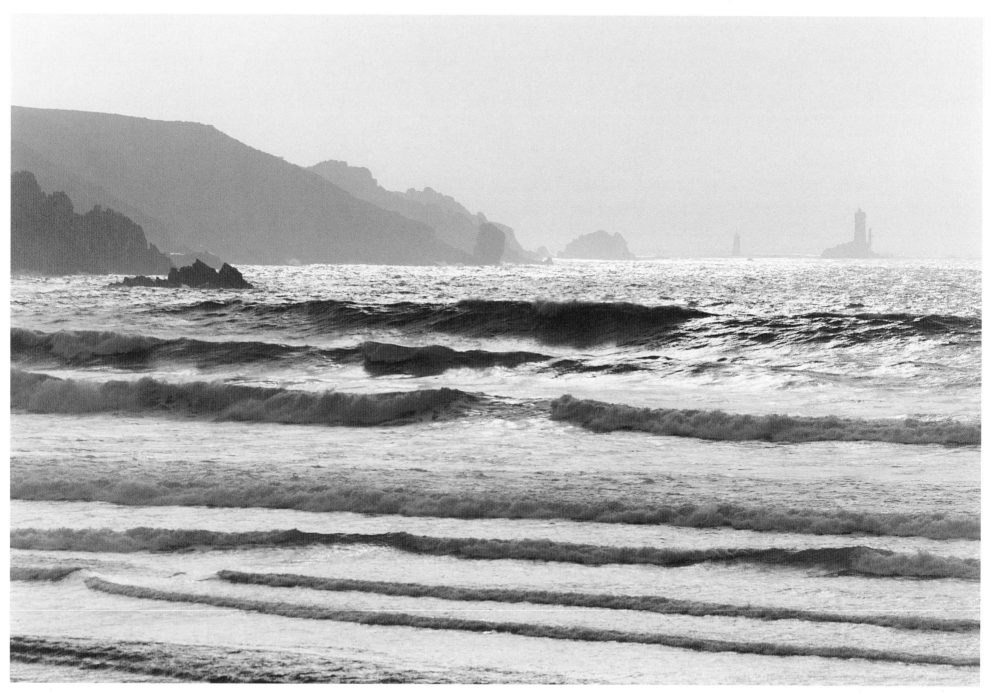

Pointe du Raz, Bretagne

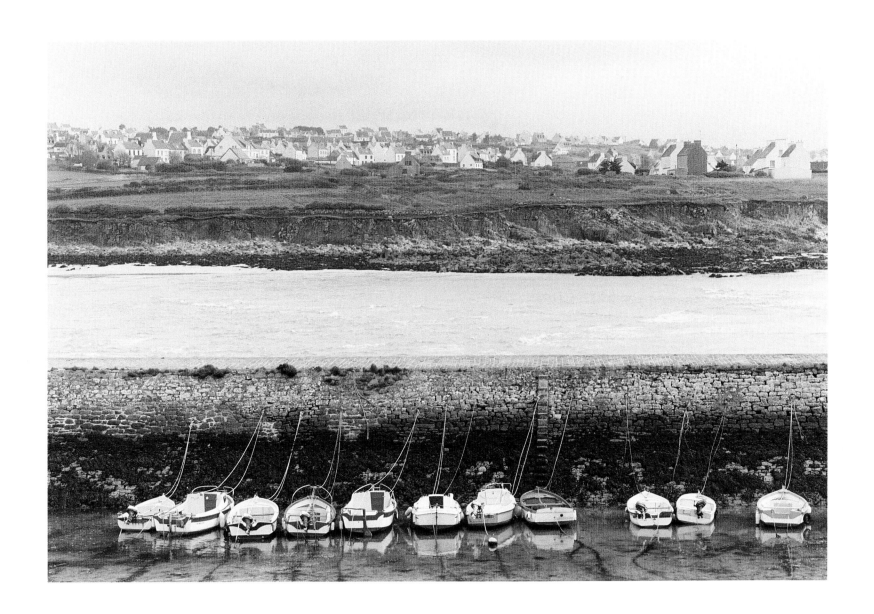

Poulgoazec, Bretagne

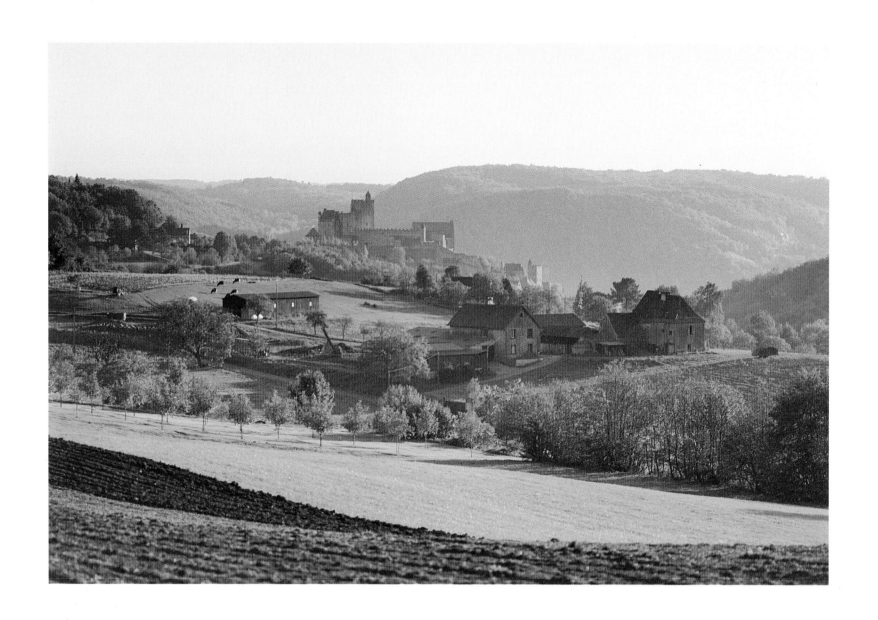

Beynac-et-Cazenac, Dordogne

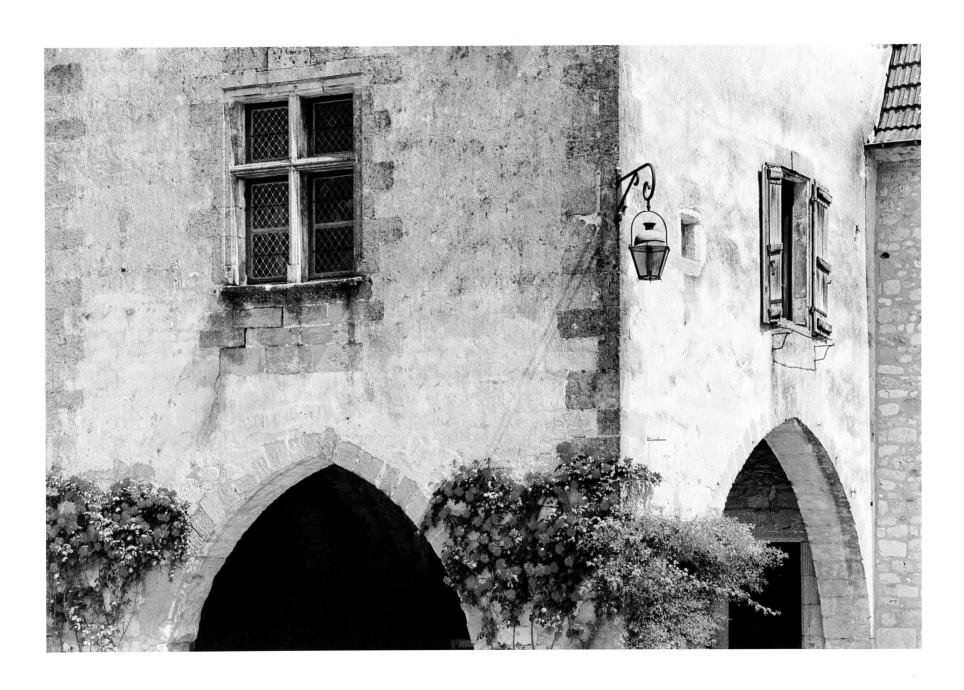

Monpazier, Dordogne

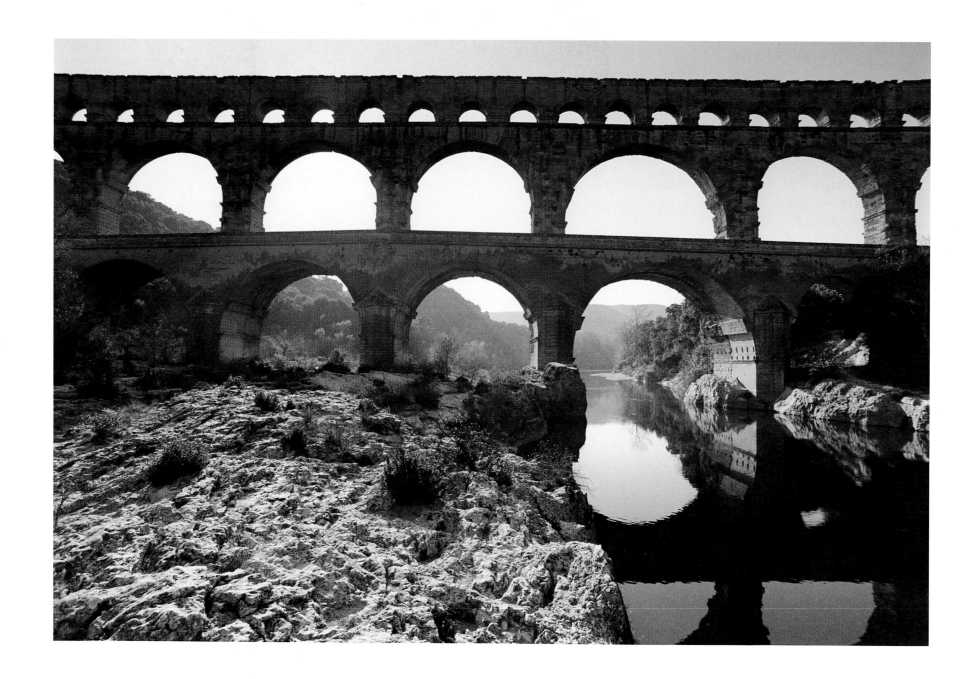

Pont du Gard, Languedoc

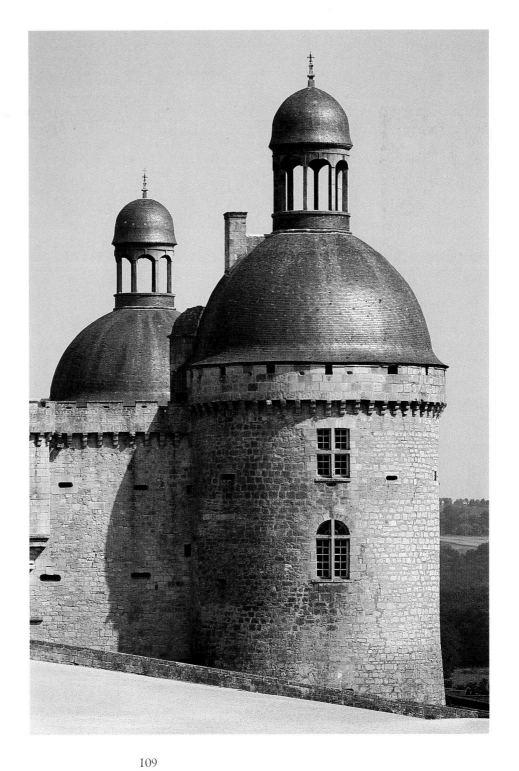

Hautefort, Périgord Vert

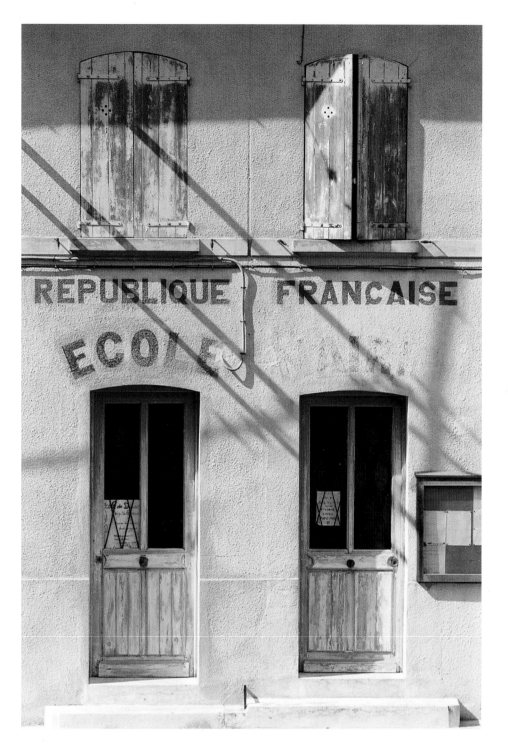

Pontevès, Provence *(left)*
Rocamadour, Lot *(opposite)*

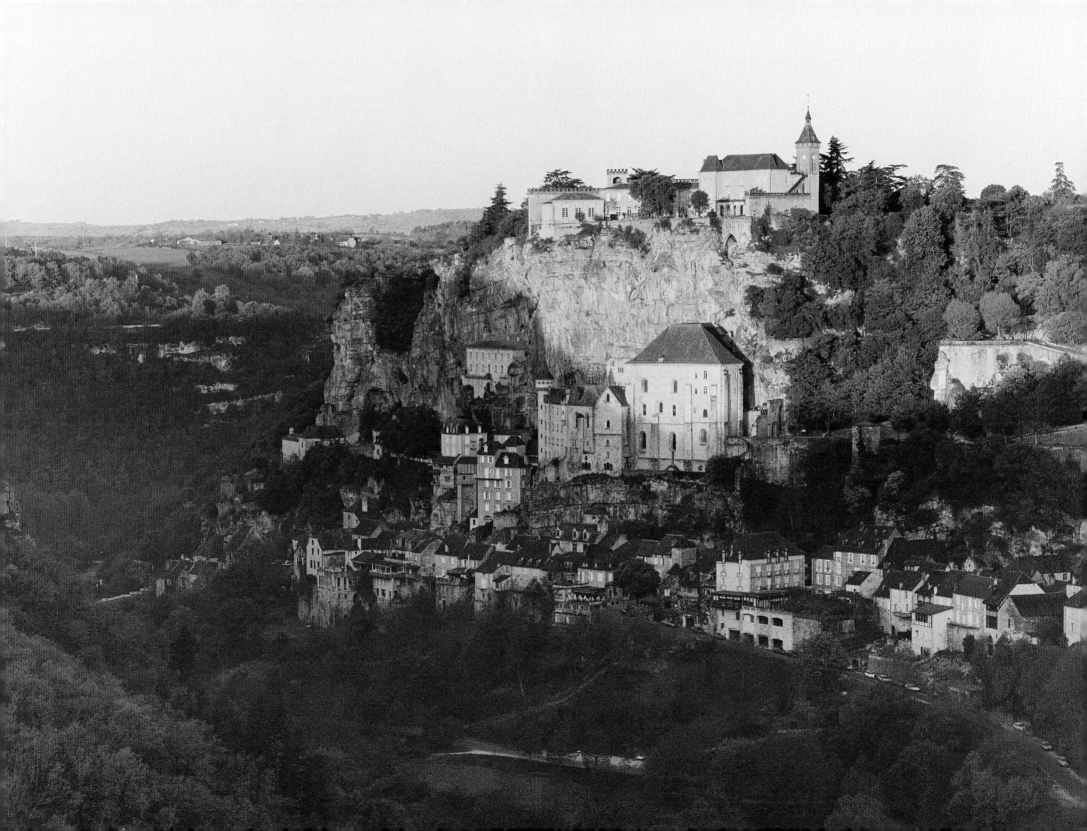

INDEX OF PLACES

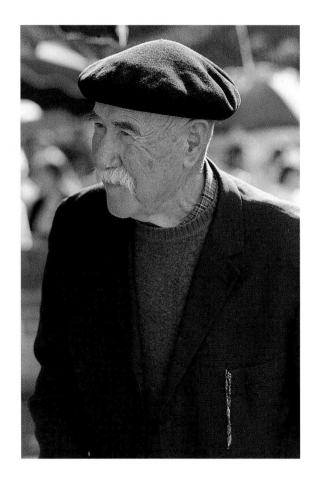